31 YEARS: GIFTS FROM MARTIN WEINSTEIN

31 YEARS: GIFTS FROM MARTIN WEINSTEIN

DAVID E. LITTLE
MINNEAPOLIS INSTITUTE OF ARTS

To the MIA's generous donors, trustees, and friends, who have made the magic of photography available to our visitors.
—DAVID E. LITTLE

To Lora, Molly, and Max, for putting up with me.
—MARTIN WEINSTEIN

CONTENTS

FOREWORD

"Did you see Martin's new show?"

"Did you stop by to visit Martin?"

All you need to say in the Minneapolis arts community is "Martin," and everyone knows whom you are talking about. "Martin" is Martin Weinstein, a beloved figure in Minneapolis arts and a prominent, vigorous advocate of photography. Martin's art gallery, the Weinstein Gallery, opened in 1996 and has been a leading catalyst for new art since, inspiring an entire generation of new collectors to appreciate and collect photography and other media. The Weinstein Gallery is well known locally and nationally for mounting elegant exhibitions that often look closely at masters of photography, such as Manuel Álvarez Bravo, Elliott Erwitt, Robert Mapplethorpe, Gordon Parks, and, more recently, W. Eugene Smith. It also represents important contemporary figures such as Robert Polidori and Alec Soth.

The Weinstein Gallery is not just a gallery. It is a gathering place, a cultural hub, a place where friends, fans, artists, and the public gather to see art and to talk with Martin. If you visit the gallery one Saturday afternoon to take in the latest exhibition, you will likely hear murmuring beneath the wooden floorboards; that would be Martin's many friends and artists talking about politics, sports, and art—in the basement. There is always a supply of Diet Coke to go with the conversation.

The Weinstein Gallery is Martin's second act after a distinguished career as an attorney at Maslon Edelman Borman & Brand. In the late 1970s, he caught the collecting bug and soon became a member of the Minneapolis Institute of Arts board of trustees and part of its history. This exhibition, "31 Years: Gifts from Martin Weinstein," is dedicated to Martin's generosity to the MIA over three decades, during which time he has given more than five hundred artworks and contributed to the museum with his knowledge and enthusiasm as a board member (1992–1998). During that time, he served on the Accessions Committee for four years (three of those years as vice chair); the Audit and Finance Committee for six years; and the Government Affairs Committee for one year. Due to Martin's countless contributions, his legacy at the museum will indeed be long.

Many thanks to organizing curator David E. Little, curator and head of the Department of Photography and New Media, for his dedication to this project and his introductory essay, "A Family of Pictures: A Collector and a Collection," which captures Martin's spirit and role in building the MIA's important photography collection. Thank you as well to Alec Soth, noted American photographer (and former MIA employee), who lent his time and insights to a conversation with David and Martin. Alec aptly coined the title, "Giving Things Back." Finally, a thank you to Martin who, in between outstanding gallery shows and a series of art fairs, gave of his time to this project to discuss the evolution of his collection. We are grateful for his contributions to the Minneapolis Institute of Arts, which audiences will enjoy and learn from for years to come.

Kaywin Feldman
Director and President
Minneapolis Institute of Arts

PREFACE AND ACKNOWLEDGMENTS

Minnesota winters are notorious, but Minnesota summers are, without a doubt, the state's most underrated and extraordinary weather experience. Few states can compete. In 2008 I traveled to Minneapolis from New York City during one such glorious summer to interview for my current post at the Minneapolis Institute of Arts. Three hours after leaving New York's smoldering-asphalt air, I was greeted by a beautiful sky with rounded clouds straight out of "The Simpsons," more shades of green than I had ever seen, and cool, fresh air. Meanwhile, the so-called state bird, the mosquito, was nowhere in sight and has remained so, at least for me, since. It was during this visit that I first met Martin Weinstein, who was full of his characteristic enthusiasm about art and the Institute. That memorable afternoon, we sat on Martin's porch in rocking chairs and talked for several hours about photography, baseball, New York, Minnesota, and family. All the while, Martin puffed on an aromatic cigar. This was the beginning of a friendship that has grown and deepened even as we've worked to create this catalogue and exhibition, "31 Years: Gifts from Martin Weinstein." I must admit that the book has been a great excuse to swap photography stories, debate the best works and artists, share theories on market trends, muse on sports, and just hang out. In many ways, this book is a continuation of the conversation that we began four years ago. I hope you enjoy listening in.

The talent and hard work of many people helped transform our conversations into a tangible catalogue. First, thanks to my generous colleagues at the MIA. Registration: Brian Kraft, Jennifer Starbright, Tanya Morrison, and Leslie Ory Lewellen. Installation: Tom Jance, Jack Buss, Mike Judy, Jonathan Hamilton, and Bill Skodje. Media and technology: Douglas Hegley, Michael Dust, and Ryan Lee. Public relations, marketing, and advancement: Anne-Marie Wagener, Tammy Pleshek, Kristin Prestegaard, Jessica Zubrzycki, Julianne Amendola, and Mary Mortenson. Special events magician Kim Supple. The stalwart publications team: Laura DeBiaso, Jim Bindas, Dan Dennehy, and digital pro Joshua Lynn. Special thanks to DeAnn Dankowski who assisted on all aspects of the catalogue and exhibition, particularly by securing image rights and patiently reediting checklist after checklist after Martin and I changed our minds each time we met. Kurt Nordwall carefully crafted each frame, and interns Jen Dolen and Kristine Clarke researched and assisted with fine wall labels. Leslie Hammons, director of the Weinstein Gallery and a consummate professional, provided good cheer and helpful assistance with catalogue and exhibition details. Matthew Rezac created an imaginative and handsome book design. A very special thank you to editor Laura Silver for her thoughtful and speedy editing of multiple drafts and her good humor throughout the editorial process. Thanks to Kaywin Feldman, director and president of the MIA, and Matthew Welch, deputy director and chief curator, two of Martin's biggest fans, who provided the support and resources necessary for the project's successful completion.

Finally, to Darsie, Sophie, and Nina, for making every season seem like a Minnesota summer.

David E. Little
Curator and Head, Department of Photography and New Media
Minneapolis Institute of Arts

FROM THE HIP

**ON SELECT PHOTOGRAPHS FROM
31 YEARS: GIFTS FROM MARTIN WEINSTEIN
PART 1**

The French poet Stéphane Mallarmé famously noted, "To define is to kill. To suggest is to create." Mallarmé expresses the conundrum of translating the visual into the linguistic. How does one convey the act of seeing and experiencing photographs without killing the pleasure and possibilities of the conversations they inspire? Indeed, do we need another biographical entry or another lesson on style to guide our interpretation of photographs? There are other ways to talk about photographs—as gossip, confession, memory, personal projection, or even wistful fiction. In truth, we might not even talk *about* photography, but *around* it. Such talk calls for looser, more subjective forms of speech—from the hip. The resulting discourse may be more unpredictable, unwieldy, rambling, broad reaching, and highly personal. It may contain suspect logic or be just plain suspect. Still, such conversation offers us a new way to understand these images. In the case of a collector, it yields insights into the collector's relationship to the object, from the specifics of its acquisition to its desired qualities as an image. (Such qualities often have little correlation to standard photographic description.) In the catalogue essay, "A Family of Pictures," Martin's photographs within the MIA's collection are contextualized in a more official style. This section, on the other hand, attempts to record an informal conversation between two people, with photographs as their point of departure.

MARTIN WEINSTEIN: Jerry Liebling was probably the youngest and one of the last members of the Photo League [a cooperative of photographers (1936–1951) based in New York, which sought to document important social and political events]. He was highly influential with young photographers and photography students at the U of M [where he taught from 1949 to 1969]. He's perhaps best remembered for images of handball players at Brighton Beach; his great image of a street rally; and certainly his images of Minnesota political figures, including Hubert Humphrey and Gene McCarthy at a U of M football game. But I happened to see this photograph locally. There was a nonprofit alternative arts program here called Film in the Cities. To raise money, the organization had an art auction, and this picture was in the auction. I think it's a very, very lyrical picture and just beautifully done. You know, there are so many reflections images and window images, starting perhaps with Eugène Atget and his pictures of dresses and suits and storefront mannequins; and it continued with people like Lisette Model, where a good portion of their careers were window images. Here, Jerry's drawing on that tradition and taking a wonderful, wonderful picture. The dress almost seems to be in motion. But it's not. It seems to be blowing in the wind inside the storefront.

DAVID E. LITTLE: It has a European, surrealist feel to it along the lines of Atget, as you mentioned earlier. Whereas Liebling is known for a completely different kind of photograph, mostly documentary. Still, if you look at this photograph and other examples of his work, he often photographs objects and their relationships in a poetic manner. It is hard to pin down, but he has an ability to make objects and layers appear lightweight. In his photograph, *Butterfly Boy, New York*, for example, the wind billows the boy's coat. This picture-making sensibility is what separated him from run-of-the-mill documentary photographers making flat-footed images with little energy, and in which the weight of the world is overdone. ▲

14

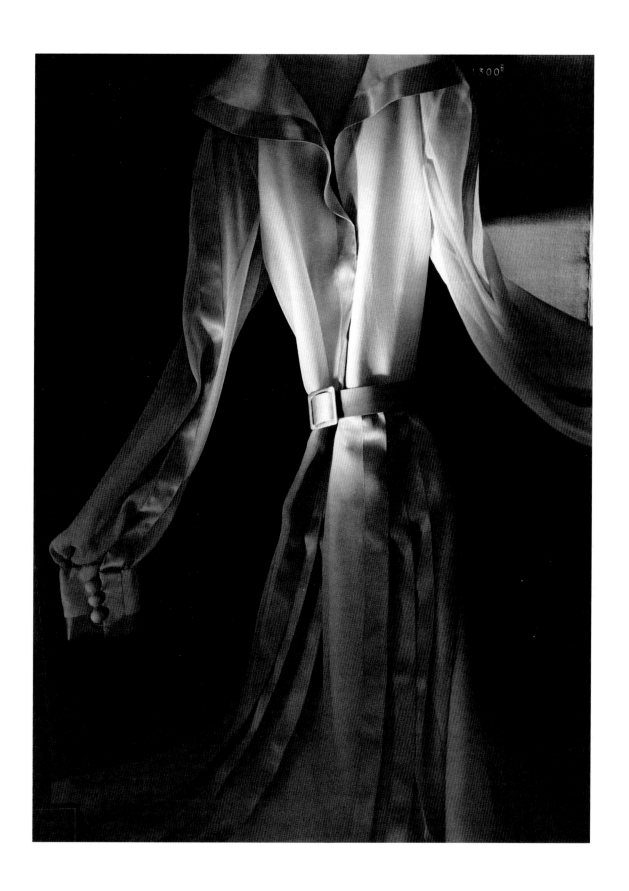

Jerome Liebling, <u>Dress, Paris, France, 1974</u>

DL: In 1997, Robert was commissioned by the *New Yorker* to do a portfolio on California modernism in Palm Springs for a piece called "Desert Cool" by Kurt Andersen. The photographs were conceived for the *New Yorker*, but they turned out to be terrific and he decided to make them available to collectors.

MW: Yes, this is a very popular print. Photographers don't typically single out their favorite photographs, especially since they shoot so many over a career. But I asked Robert one time, "Do you keep any images for yourself? What do you have at the apartment?" I'd been at his apartment and studio. And he said, "You know, one of my very favorite pictures is the *Gas Station* in Palm Springs." This one is exceptional, with the modernist structure and the palm trees waving. ▲

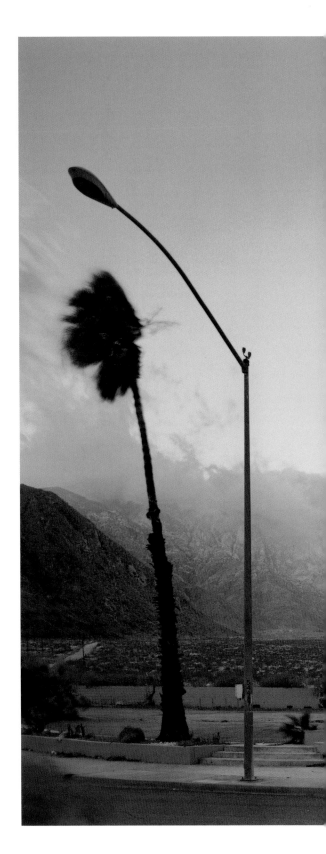

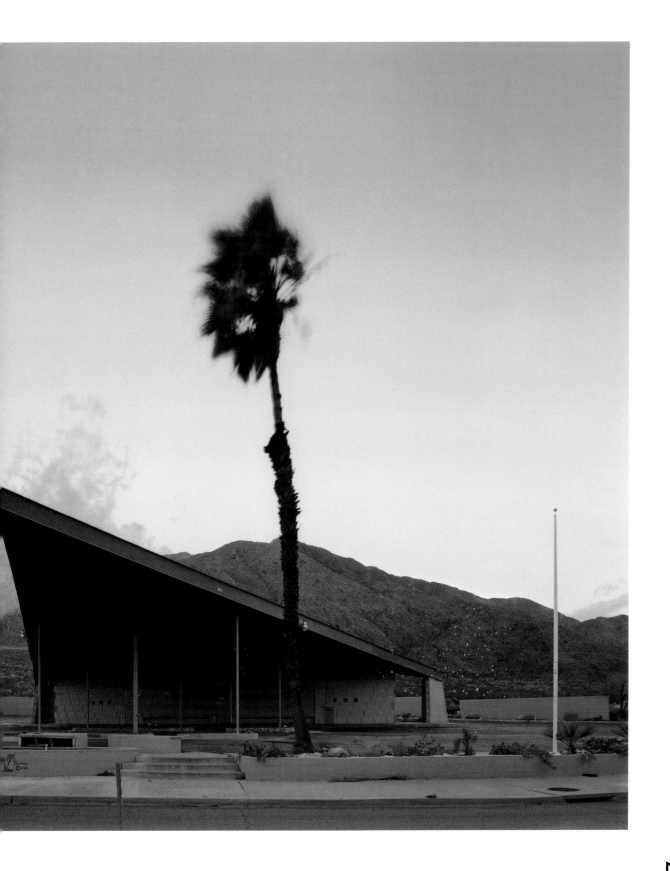

Robert Polidori, Gas Station, <u>Palm Springs</u>, 1997

MW: This photograph is from Bruce Davidson's East 100th Street series. For me, it's quintessential New York. He's shooting people, poverty, and tenements. But what I really like about this picture is that you feel like you can look into the windows or onto the fire escapes to see what's going on. He really captures New York. The building is classic New York City from the early part of the twentieth century. The picture has a great deal of humanity in it. I acquired it at a time when I was really concentrating on urban images. ▲

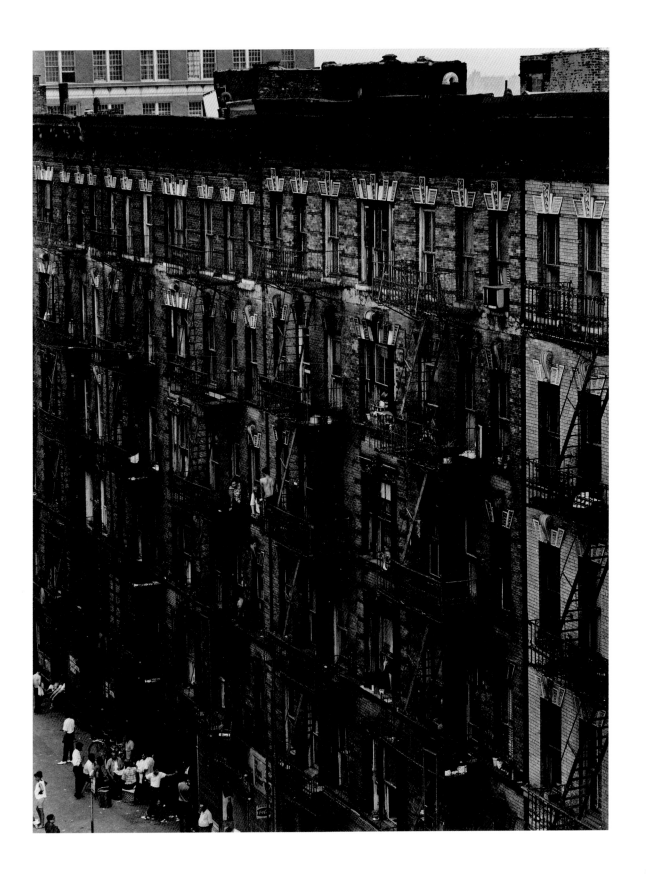

Bruce Davidson, East 100th Street, c. 1966–1968

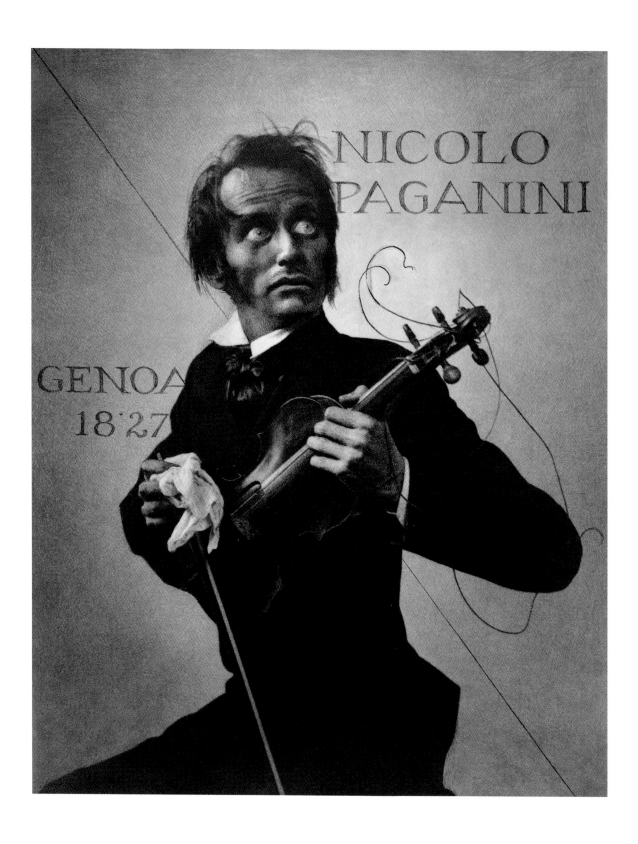

MW: It's a shame that Mortensen didn't live long enough to be editor in chief of *Mad* magazine because that's what his pictures are to me. They are bizarre and whacked-out with this incredible humor, weirdness, and mystery about them. If he had lived longer his favorite subject would have been Alfred E. Neuman. Paganini portrayed here was, they say, the greatest violin virtuoso who ever lived. But he was also very wild; his personal habits were very extreme. I think what the image of the character gets is that he was simply over the top.

DL: Mortensen died in 1965, so it turns out that he did live long enough to have been editor in chief of *Mad*. A missed opportunity, but he did make it to Hollywood. He worked in Hollywood, so it is not surprising to see how film influenced his approach to photography. He was the producer, director, and cinematographer of his photographs. He first staged them and then had a highly technical approach to photographing. He created several photography manuals during his career. ▲

MW: A number of years ago, *American Photo* magazine did a poll of their subscribers—many thousands—to see who they thought was the most important female photographer of the twentieth century. Mary Ellen Mark was mentioned repeatedly. This image was from her series on the homeless and poverty on the West Coast. The Damm family lived in the car, and they had the kids, and there's not much else you can say about it, because it is such an emotional picture. And if you don't relate to it, then I don't think photography is your medium; you're looking for something else. It's a tough, gutsy picture. It's Mary Ellen at her best. ▲

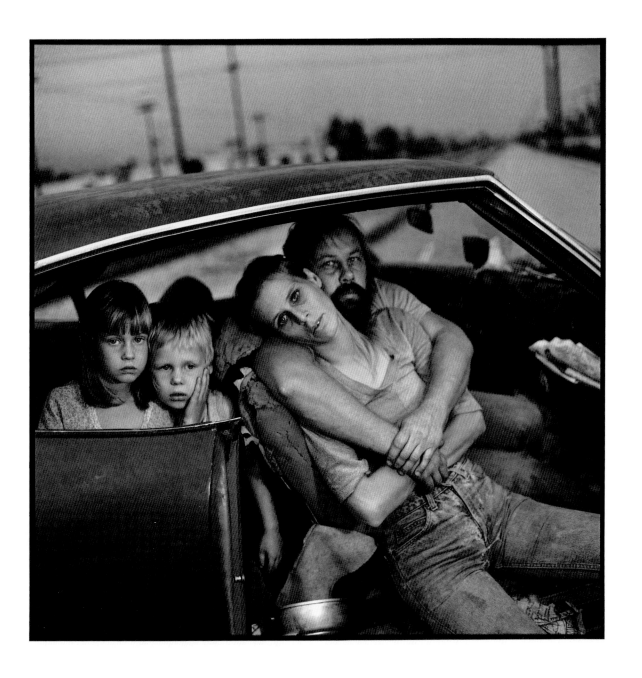

Mary Ellen Mark, <u>Homeless Damm Family in Their Car, Los Angeles, California,</u> 1987

MW: This image hung above Ted Hartwell's [the founding director of the MIA's current Department of Photography and New Media] desk for many years. And the moment I looked at it I thought, *that is a great image*. What Ted had was a small postcard reproduction of the print, so when someone offered me a vintage print some years later, I immediately snapped it up. For me, it's a great image because of the association with labor unions. You know, I grew up in a very liberal household, and I had been supporting myself, from a teenager on, with a whole host of jobs. I can't count how many unions I've belonged to because it was required to get the job—like the Teamsters. But, to me, that picture is a synopsis of the American labor movement. In Minneapolis and St. Paul, they were out in the streets in bloody riots. Here it's a peaceful assembly in 1939 which was the peak period of unionization of American industry. So it's more than black-and-white street photography. This is a pointillist painting; this could be Seurat doing a union rally. But I will also say this: the most important thing about it now is that, for me, it's Ted. ▲

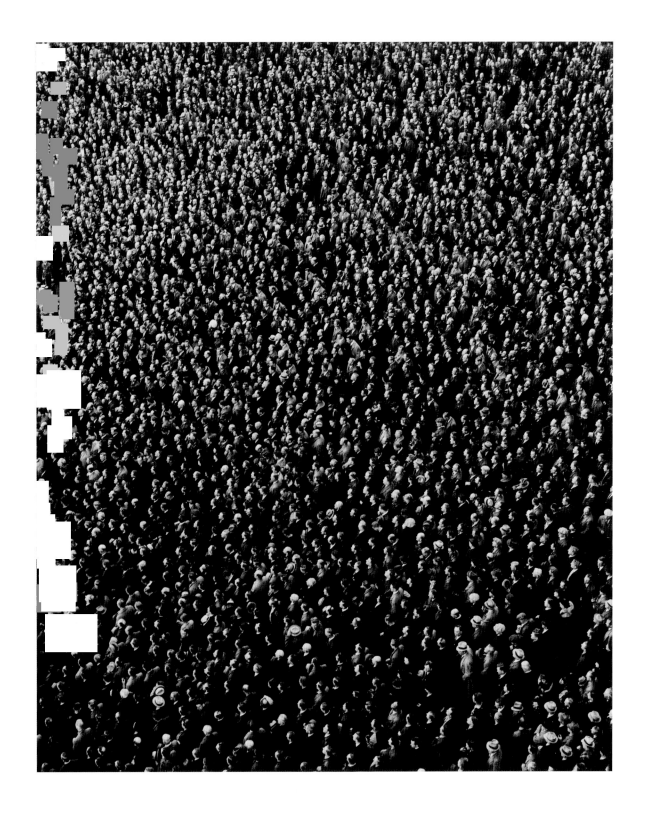

Arthur Siegel, Right of Assembly, Detroit, 1939

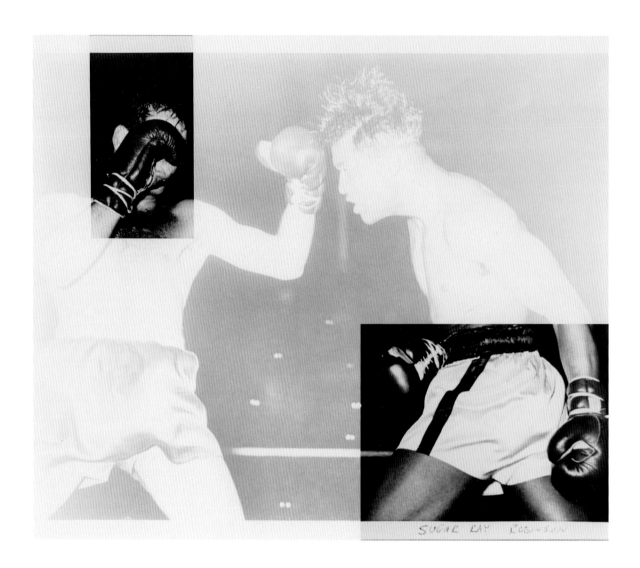

SUGAR RAY ROBINSON

Suzanne Hellmuth and Jock Reynolds, _Exchange_, 1982

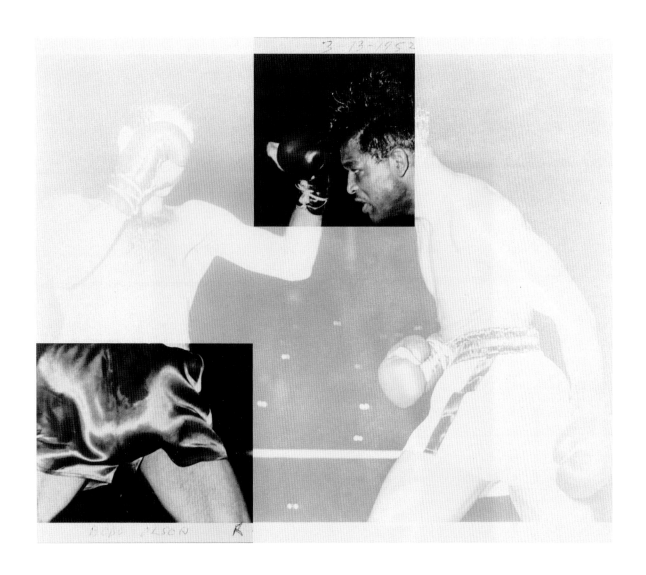

Aaron Siskind, *Rome 73*, 1963

MW: This was the first serious piece I bought as a collector, more than thirty years ago. I bought it in San Francisco in '82, the same year the photographers made the picture.

DL: Jock Reynolds, who is now the Henry J. Heinz II Director of the Yale University Art Gallery, created this triptych with his wife, Suzanne. It's not a typical picture for you; it's more experimental, a collage of images.

MW: I love boxing. I watched the fights three nights a week on TV with my father when I was ten years old. The triptych of photographs shows Sugar Ray Robinson and Carl "Bobo" Olson, who fought four times as middleweights. Sugar Ray beat Olson every time [1953–1955]. Today, you hardly ever see [Olson's] name mentioned at all. But I remember the fights. The artists pulled three different pictures from the archives at the California Historical Society in San Francisco and obviously manipulated the images. It was one, two, three. I thought it was terrific. I still think it's a great boxing sequence.

DL: I spoke with Jock last week, and he said that the triptych was part of a broader series of archive-based works that he and Suzanne produced. They were interested in archival taxonomies of images and also how histories, such as the history of California, were created in a visual form. He noted that this work was about the act of seeing and what parts of an image are emphasized. The artists call attention to sections of the image through over- and underprinting. ▲

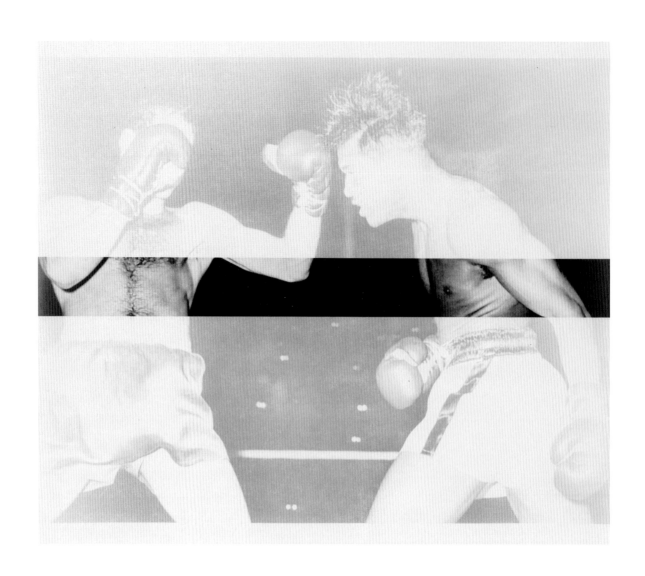

MW: I bought this image in Chicago from a dealer who specialized in Chicago-based photographers like Harry Callahan, Aaron Siskind, people who came out of the Illinois Institute of Technology Institute of Design in Chicago—founded by László Moholy-Nagy as the new Bauhaus—or were influenced by that school. Aaron was the Abstract Expressionist photographer. He exhibited at the gallery in New York where quite a number of the Abstract Expressionist painters were showing. There are certain pictures that you can look at and say, this is art history. Well, this photograph is art history. This was a time when photographers were trying to expand the universe of the photographic image—to move from realism and to deconstruct, taking forms from what are essentially wholly abstract images. What I also like about this is it's in its original frame. This glorious green Plexi frame held in place by glue and what appear to be airplane rivets. I presume that Siskind was involved with the original frame. ▲

MW: Bourke-White started her career in Cleveland. This is an early example of her precommission work before she moves on to work at the Ford plant in 1932 and produces some of the industrial images that put her on the map. This photograph represents a transition period in her career. It is of the pictorial style, seen in the tone of the picture. There's no other way to say it—it's a beautiful picture. And I thought it was good because it wasn't one of her better-known works such as the Chrysler Building or the Ford plant either. It wasn't a traditional Margaret Bourke-White, but it was where she came from, her home before she became a legend. It's illustrated in almost every one of her catalogues. ▲

Margaret Bourke-White, Terminal Tower, Cleveland, 1928

Fred G. Korth, Galvanized Sheets, c. 1948

MW: Fred Korth was a very good Chicago photographer, both a commercial photographer and pictorialist, who exhibited in salons during the same period as Drahomir Josef Ruzicka. This is a very modernist image by Korth, done in the late forties toward the end of the glory of the pictorialist era. The pictorialists showed their images in museums, camera clubs, the Royal Academy in London, the Hoboken Camera Club, and in literally every kind of venue possible. The MIA mounted leading pictorialist salon exhibitions. [Former MIA associate photo curator] Christian Peterson has documented this activity very skillfully in several publications. The pictorialists were indiscriminate. It didn't have to be the Royal Academy or the salon in one of the leading U.S. museums. They also showed at camera clubs—most of the salons were organized by the local camera clubs. To me, pictorialism was perhaps the most populist movement in art. ▲

DL: Nudes are definitely a part of your collecting.

MW: Yes. The majority of the collection is representational work, from full figure to portraiture. I think Gjon Mili is one of the underrated artists represented in the collection. He deserves greater recognition. Obviously you, David, in your own exhibition, "The Sports Show," included several great Mili photographs. He was doing his multiple exposures at a time when not too many people were doing it. You might call him the Harold Edgerton of nudes. But actually, I like this particular image; I think it's quite strong, very striking, very, very innovative. He went beyond multiple exposures. It's a new perspective on André Kertész's distortion photographs from the 1930s, which were, in a way, forerunners of what Mili was doing.

DL: I didn't really know Mili's work well until I started researching "The Sports Show." He was a great personal discovery even though I should have known his work better; he was a well-known photographer of dance for *Life* magazine beginning in 1939. The connection to Edgerton is personal. He came to the U.S. from Albania and was Edgerton's graduate student at MIT. Even though Edgerton may be better known, Mili was, in my opinion, a much better photographer. Edgerton captured the unseen with the stroboscope, producing pictures that have the feel of a science experiment. Mili's photographs of athletes, dancers, and, in this case, a walking nude *à la* Duchamp have a poetry and depth about them. ▲

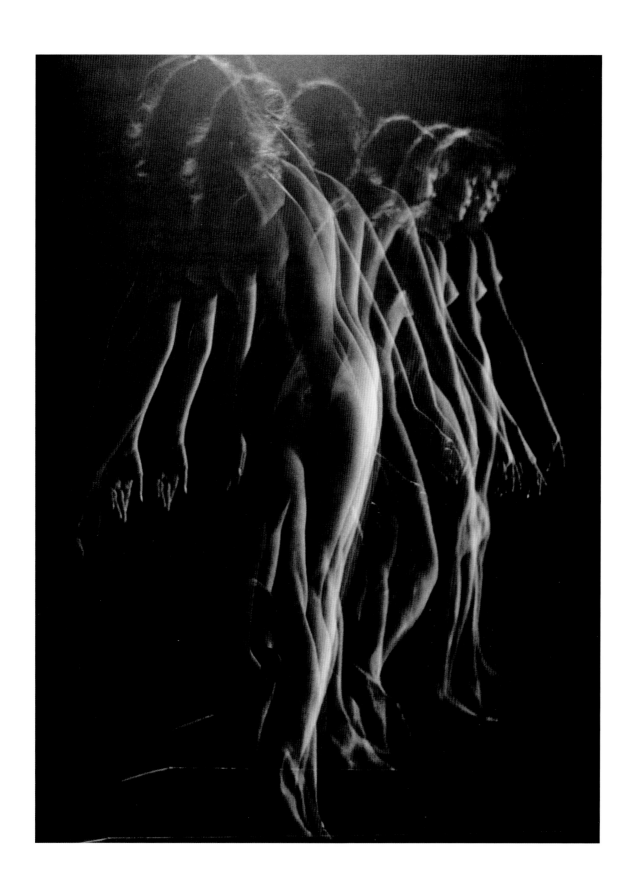

Gion Mili, <u>Untitled</u>, c. 1950

MW: I remember seeing an exhibition on the West Coast of Singh's work. They were dye transfers. Few dye transfers were being made because exposure to the chemicals is really toxic. But their rich color is unmatched. Once again, I had a personal connection to this work, because so much of my wife's family grew up in India. In any event, I thought Singh's body of work was beautiful. This particular photograph was on the back cover of one of his books. He died young, but I believe he was one of the greatest contemporary Indian photographers. He's only now beginning to get his due and recognition. About six months before he died, I had tried to reach him to do a show. ▲

Raghubir Singh, A Village Well in Dusty Winds, Jodhpur District, India, c. 1980

MW: Louis is perhaps the greatest musician of the twentieth century. I am a Ray Charles fan; I loved Horowitz's piano playing; but there's ebullience about Louis Armstrong that rises above almost any significant problem that America faces. Louis Armstrong, there's just something about him—the obstacles that he overcame, his basic good nature. But in this picture, if you notice, he's made a little hat out of a handkerchief. Well, that was a very common thing at the summer resorts in upstate New York and along the Jersey Shore. You would always see these little groups of men sitting around playing gin rummy, smoking cigars. And to protect their heads, they made the exact same kind of hat out of a little white handkerchief. As you can see, Louis is smoking away, playing gin rummy and, I have to get this out, I believe this is the Jewish star [of David]. He's just wearing it— someone gave it to him, probably his manager. There are great portraits of him with his trumpet but, wow, and the guy who took that picture is also wow—Weegee—another New York City per- sonality. I guess I'm a New York City personality. ▲

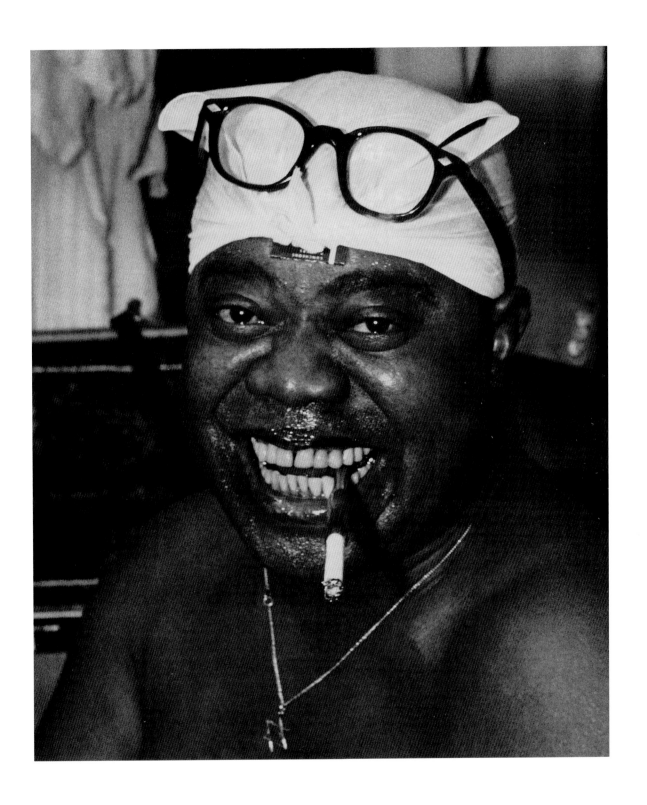

Weegee (Arthur H. Fellig), Louis Armstrong, c. 1950

El Lissitzky (Lazar Markovich Lissitzky), Model for <u>Meyerhold Theatre</u>, 1929

42

MW: Lissitzky. It's a photograph that I came upon in New York, not in a gallery show, but in the back room of a dealer's office. It was propped against the wall and I spotted it, not knowing at first that it was an El Lissitzky. It is reminiscent of his constructivist graphic design, and I could see the Russian letters on the balcony. I picked up the photograph, flipped it, and saw a label that said it was El Lissitzky. I thought it was important because El Lissitzky did many stage designs, and it would be an interesting take, both seeing El Lissitzky the graphic artist, and his architectural bent. My associate Leslie Hammons can probably tell you, "Martin never saw an image of an interior he didn't like," but I am especially drawn to well-done, well-positioned, and well-lit interiors. ▲

MW: Early on in the gallery's existence, there was a show in town at another art space—a solo exhibition of Jim Marshall's work, the great rock 'n' roll photographer. During his time in Minneapolis, he showed up at the Weinstein Gallery and loved the space and works on view. He brought along some of his work and I see this picture of Little Richard. I said, "Is that him, live?" And he said, "Yeah," and I said, "He looks like a Madame Tussauds wax statue." He says no, and mentions the concert where he took that picture. And I said, "I really, really like that picture." Several months later, an envelope arrives and there was the silver gelatin print of Little Richard, signed to me. I think they should move this to Madame Tussauds. He's incredibly beautiful—Little Richard thinks himself the most beautiful man in the world. ▲

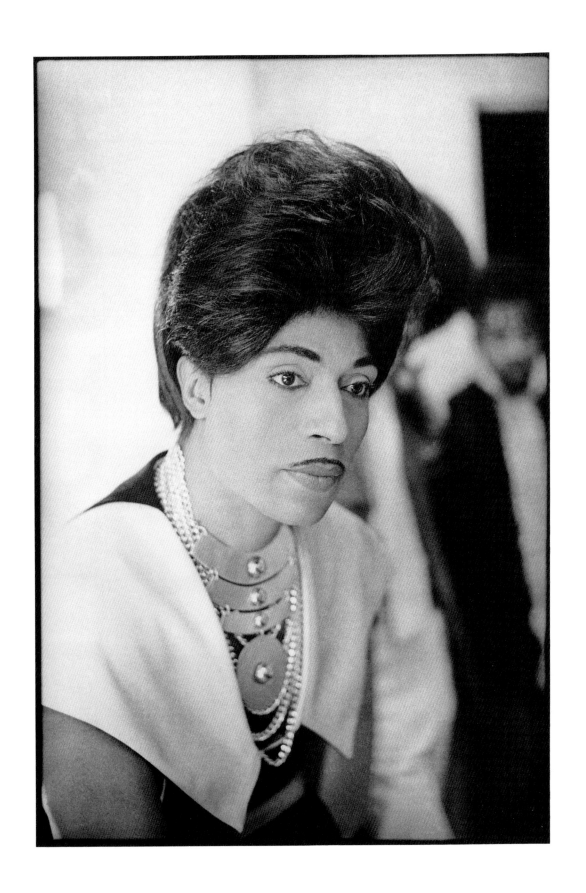

Jim Marshall, <u>Little Richard, San Francisco Civic Center</u>, 1971

A FAMILY OF PICTURES: A COLLECTOR AND A COLLECTION

DAVID E. LITTLE

Martin Weinstein has given more than five hundred photographs to the Minneapolis Institute of Arts, in addition to numerous prints, paintings, and sculptures. This catalogue and the exhibition, "31 Years: Gifts from Martin Weinstein," celebrate Martin's thirty-one years of giving, from his first gift in 1982, *Exchange* by Jock Reynolds and Suzanne Hellmuth, to his most recent four in 2013, *Paris* (1989) by Elliott Erwitt; *Falls #26* (2005) and *Martin Weinstein, Minneapolis, Minnesota* (2003) by Alec Soth; and *Thomas* (1987) by Robert Mapplethorpe. If you know people who love photographs and love the public spirit of museums, like Martin, these gifts would not surprise you. Indeed, photographs are not to hoard or keep. They are to share. This is part of their nature and charm. They are intimate objects; most are portable and can be held in one's hands. They can be easily reproduced and distributed in multiple sizes and formats. They offer traces of moments in time, stilled on flexible surfaces. They are illusive, transferable, and ephemeral. Photographs compel people to gather and tell stories about what they see. Sometimes they talk about what is represented in the picture; more often they speak of much more than what is "there." They make connections and associations beyond the formal and physical aspects of the image. They experience smells, sounds, times, and places. They remember their former selves and the lives of others. The old cliché, "a picture is worth a thousand words," surely underestimates the word count.

The photographs highlighted in Martin's collection are linked to many stories that are personal, institutional, and historical. One story is that of the *collector*, Martin Weinstein, a kid from Brooklyn, a sports fan, a teacher, a family man, and a prominent attorney, who discovers his passion for photography in the early 1970s and builds an outstanding collection. The other story is that of the Minneapolis Institute of Arts, a museum that recognizes the power of photography as "the leading and only popular visual means"[1] in the 1970s. A third story is of a *curator*, the late Carroll T. Hartwell (known as Ted), the MIA's founding curator of photography, and his long-standing friendship with Martin. And, finally, the most important story is that of a *collection*, the MIA's photography and new media collection, which brings international photography to Minnesotans.

The Collector, Collecting, and the Collection
Martin's collection of photographs is rich and diverse in content, created by international artists (mostly American and European). Although it may appear idiosyncratic at first, a pattern emerges of dominant styles and subjects. These include gritty city scenes with

working-class architecture, often of New York City, by American photographers such Margaret Bourke-White [page 33] and Bruce Davidson [page 19]; highly crafted, soft-focused, and romantic images by Czech pictorialist Drahomir Josef Ruzicka [pages 99 and 102]; and portraits of athletes, musicians, nudes, workers, children, and political figures and crowds. As with any collection, styles, subjects, and artists are excluded. There are few examples of post-1960s pop culture or conceptual, manipulated, or staged photography. Only a handful of color photographs are represented. But seemingly consistent patterns have exceptions, too. Martin's first gift to the MIA, *Exchange*, is a triptych of found images that have been collaged and manipulated. And Martin's interests have changed and grown over the years, particularly since he opened his gallery in 1996 and began devoting a majority of its exhibitions to photographs. He has added color to his collection and, in fact, represents leading color photographers such as Robert Polidori, Mike and Doug Starn, Sarah Moon, and Alec Soth. Still, Martin's first love is rooted in vintage black-and-white photography. This is reflected in his gifts and his gallery programming, which has included important retrospective exhibitions of leading, now-classic photographers such as Elliott Erwitt, Gordon Parks, August Sander, André Kertész, Mario Giacomelli, Manuel Álvarez Bravo, Robert Mapplethorpe, Mary Ellen Mark, and W. Eugene Smith.

Museums tend to collect broadly, filling in gaps in historical styles and representing many artists. But private collections are rarely dictated, or even motivated, by what might be seen as the chore of gathering a judicious range of works. They are much more personal and biographical than museum collections, reflecting different moments in collectors' lives, past and present. This is seen even (or especially) in the acquisition of the object. Museums and educated collectors are both acutely attentive to an object's provenance, the series of owners that links the work back in time to its creation by the artist. This is a key determinant of an artwork's authenticity, uniqueness, and value. But part of a collector's thrill is the collecting moment—that first encounter with the object, when desire and inspiration kindle the imagination. For a collector, purchasing an artwork can be spontaneous (while curators often have to delay gratification, as months and sometimes years pass during the acquisition process). Collectors tend to proudly store and share that moment through a story about where, when, and how an object became part of their collection. Each photograph collected has a place of purchase—bookstore, gallery, fair, artist's studio—a previous owner, and a negotiated commercial exchange, all of which become part of the history of

that object in the mind of the collector ["From the Hip," placed throughout this catalogue, includes some of these stories]. Martin finds a little-known set of Berenice Abbotts in a bookstore. An El Lissitzky is discovered in a dealer's back room. A vintage print of Ted Hartwell's favorite work is serendipitously offered up. And there are many more stories about the hunt, the discovery, the transaction into ownership, and the various people and personalities connected to the photograph.

Collectors become better picture hunters over time. Since his first find in 1982, Martin has cultivated a deep understanding and scholarship of photography's history by looking at images, talking with artists, and reading auction and art catalogues. Historical knowledge and a keen eye are two of the collector's best weapons against a fickle market and changing tastes. But photographs are much more than trophies of expert connoisseurship. That would be an investor's methodology. The best collectors seek more than widgets and dividends to count. They may even buy works that will not necessarily have long-term value; they still cannot resist a purchase because they simply "love it." Martin's motivation for collecting photographs, while informed by a keen sense of the market and photography history, is more personal than the simple story of the get. His collecting is driven by the power of photographs to spark connections, as Martin himself describes so well:

> Photographic images provide you with direct references, perhaps more so than any other art medium. When I looked at Jim Marshall's photograph [page 45], my first reaction was that it was a Madame Tussauds wax figure. I've always loved that about a photograph; whether it takes you back to childhood or another memory, you don't have to read anything into it. It's a visceral gut reaction. And that's the difference between photography and almost any other medium in art. You can see a wonderfully executed print, painting, or sculpture, and it makes you think and it makes you formulate your own artistic analysis. But for me, that direct connection and reference to your own life's experiences, I don't see how you can get that out of any other medium. To me, it's the most personal of the arts.

Indeed, photography lures the eye with the details of an image's form and surface, and then releases the mind inward to a state of memory, thought, and even dreaming. The power of photography lies, in part, in its ability to refer to things in the real world (much like a footprint in the sand refers to the foot that made the impression). This power is often described as "indexical."

The photographer and his or her subjects are present together in the same space and time, and the camera records that convergence through light, which projects, fixes, and records a physical presence on two-dimensional paper. The concept of indexicality, with its focus on the "literal" depiction, has, not surprisingly, provoked debates and problems since the invention of photography (and particularly in the Photoshop age). Martin weighs in here, suggesting that the power of photography lies as much in the associations prompted by these images as in the images themselves.

But if photographs were just about personal associations, then why collect photographs of people never known or places never visited? Why not just collect family snapshots? Most of us engage only in this form of collecting and its pleasures. The photographs in the MIA's and Martin's collections, though, do much more than record the activities of everyday events and people. They offer the possibility to tether personal experience to larger cultural events—Weegee's picture of Louis Armstrong [page 41] makes us feel that we are hanging out with the great musician. Or they can jettison our familiar milieu and provide a dash of poetry—Jerome Liebling's *Dress, Paris, France* [page 15] gives us the magic of a Parisian shop window. They also bestow upon us the artistic gifts of great photographers who create images that evoke multiple associations through color, tone, angle, juxtaposition, and, of course, timing.

Garry Winogrand's photograph of Jackie Robinson [page 65] is an example of this phenomenon. As an object, it is a photograph by Garry Winogrand, one of the most recognized American photographers of his generation. As an image, it depicts Jackie Robinson, a Hall of Fame baseball player, whose life served as an example and catalyst for civil rights for African Americans in the United States. For Martin, the picture triggers a memory of his childhood in Flatbush, Brooklyn, a lifelong love of baseball, and "the greatest job I ever had"—selling peanuts at Ebbets Field. To me, it shows Winogrand at his best, taking a furtive shot of a moment that gives us a new perspective on a person or subject. Winogrand's subject, Jackie Robinson, was part of a much-bigger narrative about baseball and integration in America. Robinson was the first African American to break the color barrier as a major league baseball player in 1947. As a college student at UCLA, he lettered in four sports—baseball, basketball, football, and track—and later played baseball in the Negro leagues before getting an opportunity to play in the major leagues. He would go on to have a Hall of Fame career. Winogrand's photograph of Robinson doesn't show us the baseball player that we typically see. Robinson is in his home,

not playing second base at Ebbets. He is retired from baseball and sits on a couch wearing a sharp suit. He fills the frame with the charisma of a star, one comfortable with the camera fixed on him. He has tossed a baseball with his right hand and watches it in midair; he holds a telephone in his left hand and seems in full conversation. Even in an unremarkable domestic setting, even without the crowd, you just know that Robinson is a star player with uncommon grace. (Martin describes it as a "natural dignity.") Even in retirement, and in a new uniform, he sits with the relaxed ease of an athlete in full control of every subtle movement of his body. The arms are loose, the wrists are flexible, and the eyes are focused. All of these ineffable attributes, which separate the average from the great, are present in the photograph, both in Robinson and Winogrand. They are the same attributes that would compel a collector, who revered Robinson as a child, to buy a photograph and make it part of his collection.

Photography at the MIA

When Martin was growing up in Flatbush, Brooklyn, in the late 1950s, the Minneapolis Institute of Arts had already established its reputation as one of America's most esteemed art museums. Like the Museum of Fine Arts in Boston, the Nelson-Atkins Museum of Art in Kansas City, the Metropolitan Museum of Art in New York, the Art Institute of Chicago, and other "encyclopedic" museums in major U.S. cities, the MIA brought the world to Minnesotans through a rich array of objects, from fine-art paintings and sculptures to decorative arts. Local visitors could see rare cultural artifacts from Africa, Egypt, Rome, Greece, China, and Japan that, without the MIA, they couldn't have seen in a lifetime.

In the early history of the MIA, the museum didn't collect photography or have a dedicated department or curator. But surprisingly, photography still had a presence at the Institute. Small exhibitions were mounted beginning in 1903 with the first "Minneapolis Photographic Salon," and later with the "Minneapolis Salon of Photography," an annual photography show sponsored by the Minneapolis Camera Club from 1934 to 1950. Still, these local shows were limited in their scope, quality, and historical import. They featured amateur photographers whose work did not reflect the breadth and quality of advanced photography at that time—the experimental photographs of the Surrealists and Russian Constructivists, the documentary images of the Farm Security Administration photographers, or the photojournalism of the Magnum Photos cooperative, just to name a few developments during this period.

But this relative absence of photography at the MIA was no different than the situation at most American museums. Museums throughout the world did not accept photography as an art form or consider it worthy of serious scholarly attention, until the Museum of Modern Art sponsored the first photography survey exhibition in 1937, "Photography 1839–1937," almost a hundred years after the medium's invention. The Museum of Modern Art founded a photography department in 1940, and it would be several decades before major museums, such as the Metropolitan Museum of Art, the San Francisco Museum of Modern Art, and the Art Institute of Chicago, would follow. Think about that. Photography was seen weekly in newspapers and magazines, on cereal boxes and billboards, in family albums, scrapbooks, educational institutions, scientific labs, and military war rooms. It was virtually everywhere in society. But it was nearly invisible in art museums. There have been many arguments as to why this was the case: Photographs were said to be made by a machine and not by the human hand. Photographs were not a unique object and could be reproduced endlessly. Photographs were easy; anyone could take a photograph! Or so it was thought. In retrospect, photography was so radically new, and conformed so poorly to existing standards of art, that no clear-cut place could be found for it in leading institutions.

Photography slowly entered museums during the first part of the twentieth century, but the 1950s proved to be its breakthrough decade. "The Family of Man," organized by Edward Steichen at the Museum of Modern Art in January 1955, was the first blockbuster photography exhibition and helped legitimize the medium at MoMA. Even though the postwar humanist theme has been thoroughly (and fairly) critiqued as idealist propaganda, its contributions to installation and photography history should not be lost.

Since its opening, "The Family of Man" has attracted over seven million people at multiple venues, and nearly three million have purchased the catalogue. Steichen, in partnership with his assistant, Wayne F. Miller, and designer, Paul Rudolph, changed the way museums approached photography and its display in "The Family of Man." Instead of showcasing one artist-genius in a monographic celebration, he included more than 500 photographs by 273 photographers from 69 countries. Instead of a traditional, monotonous display of row upon row of same-size photographs that sought to focus the audience's attention on individual works, Steichen—and Rudolph, a modernist architect who would later become the dean of the Yale School of Architecture—presented an immersive environmental experience. During a time when critic

Harold Rosenberg was discussing painting as a kind of theater produced by the painter, Steichen and Rudolph produced a veritable arena for the viewer.

Minnesotans were the first museumgoers to see "The Family of Man" outside of New York when the show was mounted at the MIA, from June 22 through July 31, 1955, as the second stop on its historic international tour. The museum's press release (Monday, May 23, 1955) announced with promotional exuberance, "The greatest photographic exhibition of all time, Carl Sandburg and Edward Steichen's 'The Family of Man,' arrived in Minneapolis today." (Sandburg wrote the catalogue introduction but did not co-curate the show.) During the exhibition's first week, five thousand people visited and one thousand books were sold. Nearly forty thousand visitors would see the summer exhibition. Despite the success of the MIA's first major photography show, almost two decades would pass before the MIA's Department of Photography would be established in 1972. Still, the exhibition represented an unprecedented level of acceptance of photography at the MIA, as well as a new recognition of the medium's place in culture and its potential to connect with audiences.

Photography continued to gain momentum at the MIA in the 1960s, with its first several acquisitions and exhibitions organized in-house. With the support of the museum's director, Anthony Morris Clark (1963–1973), Ted Hartwell became a key catalyst. Hartwell arrived at the MIA in 1962 as the staff photographer and, within a year, launched himself as a self-made curator and photography advocate within the museum. (In a similar fashion, Beaumont Newhall was a librarian with a keen interest in photography when he was asked by Alfred Barr to mount the first photography show at MoMA. This was before the professionalization of curatorship.) While making object photographs of paintings, sculpture, silver, and furniture for the exhibition "Four Centuries of American Art," organized by Carl J. Weinhardt, the MIA's director at the time (1960–1963), Hartwell mentioned to Weinhardt that "a serious gap was left by the omission of American photography."[2] Hartwell argued further, "Were we, in our intended comprehensiveness, to ignore Alfred Stieglitz, Edward Steichen, Lewis Hine, Ansel Adams, Edward Weston, Walker Evans, W. Eugene Smith, and Robert Frank?" Weinhardt listened and supported Hartwell's request to research the major photography collections at the Metropolitan Museum of Art, the Museum of Modern Art, the George Eastman House, and the Art Institute of Chicago. As a result, the four institutions lent 125 photographs for the exhibition "A Century of American

Photography, 1860–1960," which opened in November 1963. The following year, Hartwell curated "The Aesthetic of Photography: The Direct Approach," which "attempted to demonstrate systematically that in its unaltered and most basic technical application the photograph does provide a vehicle for personal artistic expression and as such can be said to have a distinct aesthetic character of its own."[3] The two exhibitions, which laid out the historical and aesthetic importance of photography, marked the beginning of the MIA's photography exhibition program. This program would continue through the 1960s with a focus on contemporary developments in the field, adding to the quickly reified history of early American photography.

The early 1970s was the most significant moment in the history of photography at the MIA, marking the most important exhibition in the department's history, "Avedon" (1971), and the official formation of the department within the museum (1972). "Avedon" was the first major museum exhibition of non-fashion photographs by Richard Avedon, one of the most famous living photographers at the time. The catalogue introduction, written by the museum's director, Anthony M. Clark, and organizing curator, Ted Hartwell, points to changing attitudes about photography and its new, populist status at the MIA as having made such a radical show possible:

> Photographs are always with us now in a numberlessness obviously more plentiful than words. Few of the images more than record or pretend, few are true or memorable. Modern photography as an art has been the most delicate of all the arts—fighting (or being fought by) painting, disesteemed by the critics in favor of "the fine arts," struggling to be fit for a museum (a museum of all things!), and so forth. This is all unnecessary and unseemly, since photography is the leading and only popular visual means. In Avedon you know that what you see is art of the highest standards and power, a work important and good. Without artifice, morally and aesthetically inspired, photography and a man are behaving as they well might. The results belong to all of us.[4]

Coming from the commercial realm, much like Steichen, Avedon understood how to exploit the "popular visual means" of photography. He teamed up with Marvin Israel, an art director at *Harper's Bazaar*, *Seventeen* magazine, and *Mademoiselle*, to create an exuberant and theatrical display space with silver walls and a black ceiling. A then-unknown photographer, Diane Arbus, joined Avedon

and Israel in Minneapolis to mount the show. (She later pitched her new portfolio, *A Box of Ten Photographs*, to Ted for purchase. It is now a rare classic of the period and a cornerstone of the MIA's collection.) The photographs on view featured a range of recognizable and familiar cultural figures, from politicians (President Eisenhower) to movie stars (Charlie Chaplin and Buster Keaton) to pop icons (Marilyn Monroe), whose portraits were simply pinned to the wall in the free-form manner of a freshman dorm room or a fashion magazine editor's bulletin board. The most stunning and prescient contributions to the show were wall-size murals of leading figures of the day, such as the Chicago Seven (Abbie Hoffman, Jerry Rubin, David Dellinger, Tom Hayden, Rennie Davis, John Froines, and Lee Weiner). No one in Minneapolis had ever experienced the powerful presence of such large-scale black-and-white prints on museum walls. Moreover, these photographs were hot off the presses. They were "now" and in the news. The aim, of course, was highly intentional—to provoke the traditional museum-going audience and perhaps even to call out to a new, youthful one. Avedon added more fuel to this already combustible mixture by handing out opening invitations to panhandlers throughout Minneapolis. Avedon had, indeed, come to Minneapolis, and few would forget it and Ted's role in making it happen.

Based on the success of the Avedon exhibition, one might assume that Hartwell would continue in a similar vein of collecting and exhibiting once he became the head of the Department of Photography one year later, in 1972. But that was not the case. Only a handful of contemporary fashion photographers—and only a single portfolio from the Avedon exhibition (which is now called the *Minneapolis Portfolio*)—are part of the collection. Instead, throughout the 1970s and early 1980s, Hartwell was determined to focus on three areas of collecting: the pictorialist roots of photography as a fine art, as represented in the MIA's first acquisition of Alfred Stieglitz's quarterly journal, *Camera Work*; the subjects (cities, street scenes, architectural forms, etc.) and rigorous formal style of what Hartwell called "direct" photography; and the powerful genre of photojournalism, particularly as practiced internationally by Magnum photographers. He then proceeded to educate the public with a range of exhibitions that mirrored his collection mission, including exhibitions on *Camera Work* and classic modernist photographers such as Edward Steichen, Henri Cartier-Bresson, and Lee Friedlander. When he could not draw from the collection, he contracted important traveling exhibitions from the Museum of Modern Art, the Philadelphia Museum of Art, and the San Francisco Museum of Modern Art. Many came from

his Midwestern peer and friend, John Szarkowski at MoMA, who lent now-historic exhibitions on Ansel Adams, Eugène Atget, and Japanese photography to the MIA. Through these self-organized and borrowed exhibitions, Ted presented the best of the history of photography in his home state. It was at this moment of expansion and diversification of the collection that he met a young collector named Martin Weinstein.

Ted and Martin

The dynamic growth in photography at the MIA from the 1950s through the 1970s was partly the product of a general acceptance of the medium in cultural institutions. But specifically, it resulted from the fervent advocacy of Ted Hartwell, a series of supportive directors, and the foresight of generous patrons who funded this new discipline at the MIA.[5] In the 1980s, photography gained another key advocate in Martin Weinstein.[6] Weinstein arrived in Minneapolis in 1971, a year before Ted was appointed the first curator of the newly established Department of Photography. Martin worked with multinational clients on antitrust cases, traveling the world from South America to Asia. During the 1970s, he dedicated his time to law and raising a young family—his son, Max, and daughter, Molly—with his wife, Lora. In the early 1980s he caught the collecting bug. There was little indication from Martin's background—a kid from Brooklyn, a high school social studies teacher, and a lawyer—to foretell his passion for photographs. His only connections to art were his mother (a musician) and a childhood interest in building dioramas. Indeed, given Martin's love of sports, it was more likely that he would collect baseball paraphernalia. Martin, though, is a curious and serious man, with intellectual and political interests, the eye of a connoisseur, and an appreciation for the art of the deal.

Nearly a decade would pass before Martin and Ted crossed paths in Minneapolis with, ironically, a Richard Avedon photograph as their matchmaker. About 1980, Martin contemplated a major purchase from a San Francisco dealer, an Avedon photograph of a little boy standing in front of a tree in Sicily after World War II. Here is Martin's recollection:

> I remember the dealer saying, "You know, I don't know too many people who buy photography in Minnesota. But they do have a really cool, great guy—the curator at the Institute—one of the few photography curators in the country, Ted Hartwell. You and he ought to get together." I didn't know Ted, and I sort of filed it away. A few months later, for whatever reason,

I was at the MIA and I wandered over to the photography department, which was an incredibly accessible place. I introduced myself to Ted and told him I'd bought a few pictures. Well, it was an instant love affair. We got along fabulously.

This enduring friendship had photography as its bond. The two didn't always love the same pictures, but they shared a sensibility: a belief in the power of photography to offer an aesthetic framing of the world, to dramatize the daily lives of people and events. They both loved black-and-white photography, urban settings, foreign locations, historical moments, stars, girls, and bawdy humor. Ted loved the tougher side of life, the rebellious sixties, with motorcycles, prisoners, bikers, hipsters, and war pictures. More of a fifties guy, Martin loved kids and photographs about history. Both liked people in pictures and admired the underdog, the survivor, and the worker, fighting for their places in society. One picture that stands out in this regard is Arthur Siegel's *Right of Assembly, Detroit* [page 25]. Martin recalls that an old reproduction hung on Ted's bulletin board. Tiny heads (and nearly microscopic fedoras) fill every part of the print surface beyond the frame to depict a mass of humanity. This is the great crowd, citizens and workers showing their right in a democracy to rally and protest. As a token of their friendship, Martin eventually bought Ted a real print of the work to add to the collection.

Martin's gifts complemented the three main areas of Ted's collecting interest within the department: pictorialism (the pictorialist focus was developed particularly by associate curator Christian Peterson, a specialist who collected and published extensively on the genre); direct photography; and photojournalism. Here is how Ted described the relationship:

Martin's collection, which has now become the Institute's, was formed through his continuous collaboration with the Department of Photography's curators. Curators are gratified when they are sought out for their knowledge and expertise, much as teachers are heartened by motivated students.[7]

Martin acted, in part, as a third curator in the department, expanding on the foundation of the collection to round out Ted and Christian's acquisitions. In this sense, curators are not that different from collectors. We hunt, too, for works for the collection. But collectors are the envy of curators because they can select and purchase with speed and efficiency. They can take risks that curators, with their fiduciary responsibility to the museum,

must sometimes temper or moderate. Collectors do not begin with preexisting collections that circumscribe and motivate their collecting strategy, or with committees to approve their selection, and so on. If a collector makes a "mistake" or wants simply to change the nature of his or her collection, the works can be sold or given away. Curators, of course, cannot do this. They must think about the long-term impact of their collecting and how that collecting relates to an already-existing collection of works and to the history of the institution. It is difficult for museums to deaccession works (one reason that curators often prefer to take select works rather than entire collections from collectors).

Martin's three most recent gifts to the MIA—*Paris* by Elliott Erwitt [page 113]; and *Falls #26* [page 70] and *Martin Weinstein, Minneapolis, Minnesota* by Alec Soth [page 117]—continue a long-running dialogue between the two old friends. Erwitt, a Magnum member, captures a dog in full flight and the fleeting humor of an everyday moment. And it is fitting that the gift includes two large-scale color photographs by Alec Soth, a former MIA employee, Magnum member, and an artist represented by Martin's Weinstein Gallery. Soth provides two images of America that are both contradictory and coherent: the grandeur of Niagara Falls and the simplicity of a guy with a cigar, Martin, standing in front of his garage in Minneapolis. Soth follows in a grand tradition of Minnesota photographers who are part of the MIA's collection and have a connection to the museum, from Jerry Liebling, the father of Minnesota photography, Frank Gohlke, Stuart Klipper, Tom Arndt, Ramon Muxter, James Henkel, Gary Hallman, JoAnn Verburg, David Goldes, and Paul Shambroom, to a new generation of photographers that includes Katherine Turczan, and Xavier Tavera. As I was writing this essay, Martin added a fourth gift, *Thomas* [page 114], the first gelatin silver print by Robert Mapplethorpe in the collection. Mapplethorpe, as Martin notes correctly, was one of the first photographers to cross over from the specialized field of photography to the general art market. In *Thomas*, the muscular model is posed in a rounded sprinter's crouch, emphasizing the formal beauty and elegance of the body as an abstract object. It updates and complements modernist nude portraits in the collection, such as Harry Callahan's *Eleanor* (1947) and Ruth Bernhard's *In the Box/Horizontal* (1962).

Martin's recent gifts enhance the photography and new media department's new collection plan, established in 2009 to increase holdings of photography since the 1960s from around the globe. The plan was inspired by the 2007 Target Wing addition, a new Photography Study Room, and a generous gift from Linda and

Larry Perlman, who underwrote a new gallery dedicated to contemporary and large-scale color photography. During the past four years, the Linda and Lawrence Perlman Gallery has hosted the contemporary photography series, New Pictures, which has featured experimental photography by leading artists from Japan, Germany, Great Britain, Canada, and the United States. The Perlmans' gifts have added to the profound and ongoing contributions of Alfred and Ingrid Harrison in support of masterpiece photographs. (In 1992, the Harrisons dedicated a photography gallery to the memory of their son, Martin, and have since funded the collection's most important acquisitions, such as Dorothea Lange's *Migrant Mother*.) These new and exciting ventures are all built upon the legacy of Ted Hartwell's and Christian Peterson's work, with which Martin is closely associated.

Photography has now established its place in the museum, but it has an even more powerful position in the "world of images," with audiences that far exceed those for religious paintings or salon artworks of the past. Photography is the most accessible, generative, and ubiquitous art form of the twenty-first century. It has become today's lingua franca, trafficked by the billions across the globe, especially by emerging generations. As we encounter these mutable digital images—which appear and then disappear in an instant—on a daily basis, it is even more important and vital that we have exquisitely printed photographic artworks for museum visitors to study and enjoy. (Who knows? Perhaps these could become the old master prints of the future.)

If you spend a lot of time looking at photographs with Martin, which I have had the pleasure to do on many occasions, you'll see his exuberance and joy when coming face-to-face with a photograph he loves. He will burst out with, "That's a killer!" Such photographs are a rarity among the billions of photographs produced daily, and we are delighted that we will be able to share Martin's "killers" with MIA visitors for years to come.

Notes

1 Anthony M. Clark, *Avedon* (Minneapolis: Minneapolis Institute of Arts, 1971), p. 1.

2 Carroll T. Hartwell, *The Making of a Collection: Photographs from the Minneapolis Institute of Arts* (New York: Aperture, 1984), p. 6.

3 Ibid., p. 7.

4 Clark, *Avedon*, p. 1.

5 Photography could not have been possible without several key supporters who generously funded photography purchases long before it was a popular and collected art form. In the department's formative stages in the 1960s and 1970s, Kate and Hall James Peterson provided an initial five-year gift to purchase photographs; Julia Marshall and an anonymous donor brought two copies of *Camera Work* to the collection. In the 1980s and 1990s, Harry Drake and other members of the Photography Group supported Ted's programs. In 1992, Alfred and Ingrid Lenz Harrison dedicated the MIA photography gallery to the memory of their son, Martin, and established a generous fund to purchase masterpiece photographs. This fund has really been the backbone of collecting at the MIA ever since. Other supporters have included David and Mary Parker, Fred and Ellen Wells, and Clara and Walter McCarthy. Linda and Lawrence Perlman established the Perlman Gallery in 2007, dedicated to contemporary and large-scale color photography.

6 Martin was active at the MIA beyond collecting. He was a member of the board from 1992 to 1998, serving on the Accessions Committee for four years, the Audit and Finance Committee for six years, and the Government Affairs Committee for one year.

7 Carroll T. Hartwell, *Martin's Gifts* (Minneapolis: Minneapolis Institute of Arts, 1992), p. 4.

FROM THE HIP

ON SELECT PHOTOGRAPHS FROM
31 YEARS: GIFTS FROM MARTIN WEINSTEIN

MARTIN WEINSTEIN: As much as I loved being a teacher, and I really did enjoy my career as a lawyer, and I'm so obviously passionate about the gallery, I still think perhaps the greatest job I ever had, truly the most enjoyable, was as a peanut vendor as a fourteen- and fifteen-year-old at Ebbets Field. The reason being is that the Brooklyn Dodgers represented the soul of Brooklyn at the time. No doubt about it, the Brooklyn Dodgers—you lived, breathed, and died for them. Your father lived, breathed, and died for them. And, to me, a vendor at Ebbets Field was like: what do you want to be in life and have your dream come true when you're fourteen years old?

This picture reminded me of that time. There you were before the games and after the games; because when the stands were empty and the players were practicing or having pregame practice or coming out or going into the game, you had contact with them all. And Jackie Robinson was perhaps one of the most magnetic athletes who ever lived. I mean, his magnetism was palpable, yet he was very soft spoken. He was also an incredibly bright man, very well educated, and had been something like a four-sport champion in college. He was a great track star, great football player, great basketball player, and a great baseball player. This picture by Winogrand was taken after his career was over for several years; he retired in 1956. This is at his home in Connecticut (he lived very close to Philip Johnson's Glass House). He died very young because of diabetes, at age fifty-three. He was very outspoken about African Americans in the management of baseball teams. It's interesting: I'm also looking at this picture of Louis Armstrong [page 41], who, at the time, was criticized—by some blacks and whites—for not being at the forefront of the civil rights cause. I look at Louis Armstrong, and I look at Jackie Robinson. They weren't at the forefront of the civil rights cause; they *were* the civil rights cause.

DAVID E. LITTLE: I speak about this picture in my introductory essay, how I've always liked Winogrand's amazing knack for capturing unfamiliar, unposed aspects of stars and everyday people. Many photographers try to create spontaneous photographs, like Winogrand's, but few succeed. This is one of his best sports photographs. But I would rank others before Winogrand when it comes to sports images, such as his friend Tod Papageorge and old *Look* magazine colleague Stanley Kubrick. ▲

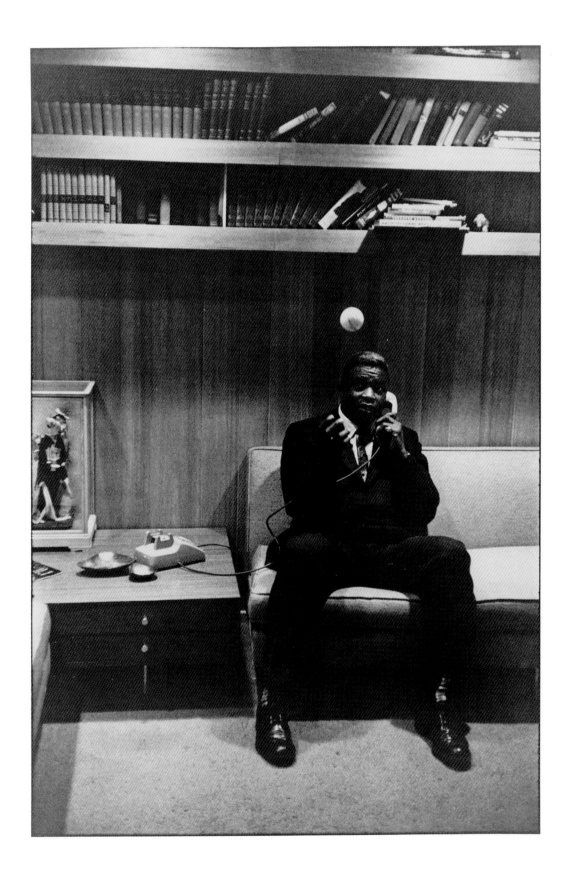

Garry Winogrand, Jackie Robinson at Home in Connecticut, 1961

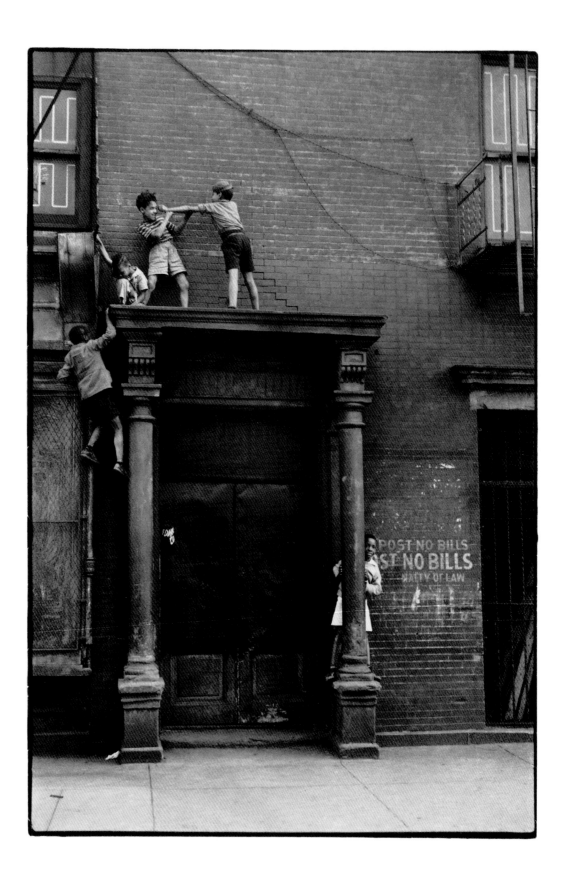

Helen Levitt, _New York_, c. 1942

MW: This photograph is also one of the very earliest pieces that I bought. In my opinion, this has got to be one of Levitt's great pictures. Once again, it incorporates the city and kids, two of my favorite themes. This is a quintessential image of the city that I grew up in and the kids who were in that city. The kids are poised, fighting over the arch, probably a public school. I attended and later taught in a public school like this in Brooklyn.

DL: Levitt understands the playful and creative spirit of children. [Photography critic and curator] Nancy Newhall dedicated an entire MoMA exhibition to Levitt's photographs of children in 1943. Levitt was self-taught and very determined; she was one of the few female photographers recognized early in the field's history, with work featured in MoMA's inaugural photography exhibition in 1937. Looking at this picture, it is funny to consider the likely response of a parent today: "Get those kids down from the door molding. They could fall. It's dangerous!" Yes, they could, but everything seems to be fine in this photograph. These children are joyful and carefree, tussling and making things up as they go along in the city, creating playhouses and games out of objects found in the street. ▲

MW: I don't think there are too many portrait photographers who haven't in one way or another been influenced by August Sander. In *Face of Our Time* (*Antlitz der Zeit*) [his first book, which contains sixty portraits], Sander sought to create a typology of the German people. I don't know who's created a larger body of work of great portraits than August Sander. The first one that I saw was the *Bricklayer*. This print was made by Gunther Sander, his son. You know, Sander stopped making portraits after the Nazis banned *Face of Our Time*. [In portraying Germans of all classes and walks of life, Sander's portraits presented a Germany of equality and diversity, qualities incompatible with Nazi philosophy.] Sander, who was not Jewish himself, was very friendly with many of the Jewish artists living in Cologne—people like Max Ernst and others—where he had his studio. He was a zealous anti-Nazi, but he knew that if he valued his life, he'd have to stop making portraits. So thereafter he made landscapes only. In fact, when the Nazis came into power and blacklisted his portrait work, they seized the plates for the book—not the negatives but the plates from which the book was made. And then later on, his negatives were buried because of the Allied bombing of Cologne. But what's interesting is, he was forever fighting the Nazis, including knocking one down the stairs to his studio. I don't know how he got away with it. I would have Sander in a show every week if I could. ▲

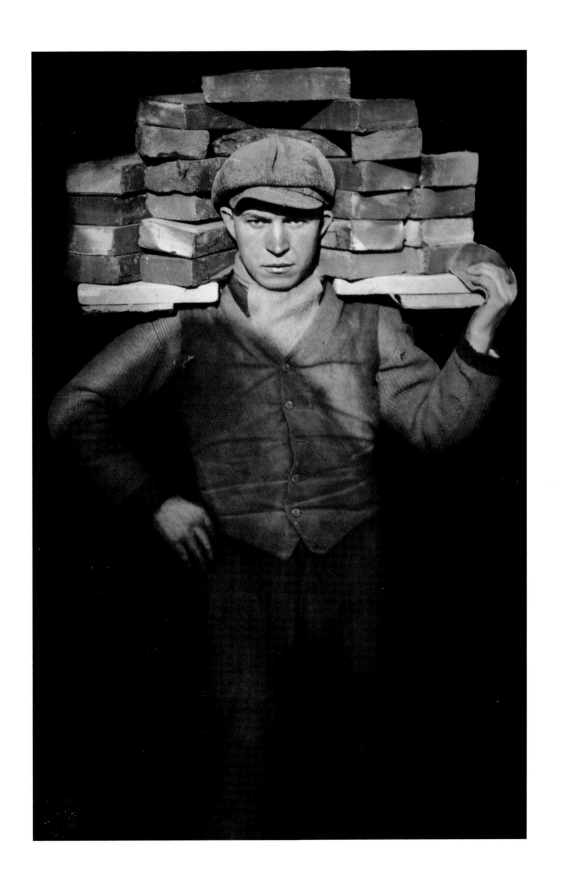

August Sander, <u>Bricklayer</u>, 1928

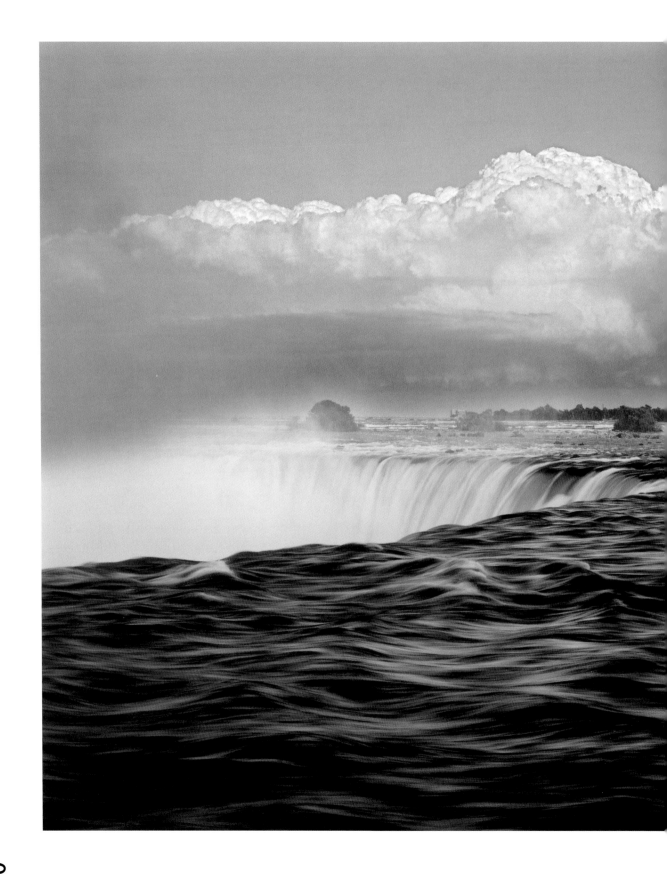

MW: This is part of the Niagara project, which Alec did after his Sleeping by the Mississippi series brought him so much attention. Alec photographed both the American and Canadian sides of the falls. He was trying to project the majesty of the area as well as the tackiness. He did a number of pictures of the falls, but two of them really stand out. Perhaps the greatest one is this particular image, which I think is magnificent.

DL: Much of the Niagara series is about tackiness, camp, even lost love. The series follows the tradition of gritty color photography of America's underbelly, begun by William Eggleston. It also conjures the cinematic anxiety, emptiness, and impending violence found in David Lynch's or Quentin Tarantino's America. But, Martin, I think this photograph of Niagara Falls, in all of its beauty and grandeur, is akin to a "tell" in a poker game. It's an unconscious gesture, a tick. Alec suggests what he has in his hand. He crops out the cynicism, blight, psychological angst, and the poverty and suggests a secret, hopeful belief in the American dream and its romanticism of possibility. You rarely get a sense of this sanguine viewpoint in Eggleston, especially on this scale. But this longing for what has been lost might be the fuel that makes Alec's other pictures so urgent and often biting. He might just care that something has been lost. Eggleston doesn't seem to care about anything. ▲

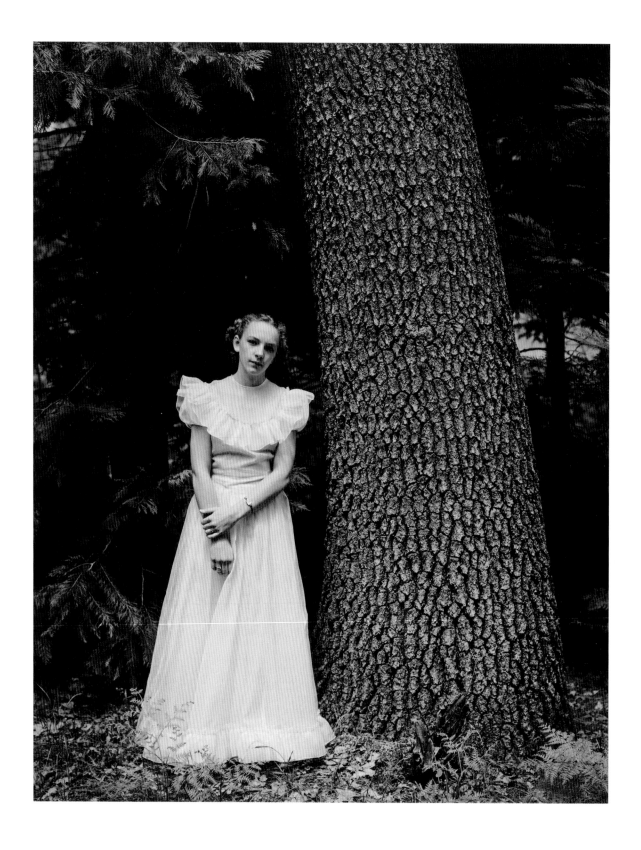

Ansel Adams, Graduation Dress, Yosemite Valley, California, 1948

DL: The MIA has sixty-four photographs by Ansel Adams. Most are classic Adams landscapes—including *Moonrise*—that audiences would recognize as masterpieces. I love pictures, though, that show another side of an artist. So when I added a new Adams to the collection a few years ago, I selected an unusual still life of scissors and a thread. This is another unusual image by Adams, whose works are grandiose and strangely cold. Adams tends to place himself and the viewer at a great distance from a scene, objectifying the landscape while making the viewer seem small. This picture of a young woman in a graduation dress has a human scale and sentiment. It shows Adams's range beyond that of a landscape photographer, yet, as in all his landscapes, he's still primarily concerned with form and a sense of nature writ large. One sees this in how he connects human and natural form through the leaning postures of the woman and tree. ▲

MW: Omar Goldbeck was fantastic with his panoramic revolving camera. I've always liked this image and quite a number of his other images, like the group portrait of the 1926 Brooklyn Dodgers and of Babe Ruth and the Yankees in 1922. But this baptismal picture is so powerful. I love the photographer—another photographer—behind the camera. Goldbeck spent more than forty years doing images of large groups of people. I do have to admit that I've blocked out of my mind that he also took photographs of Ku Klux Klan rallies. ▲

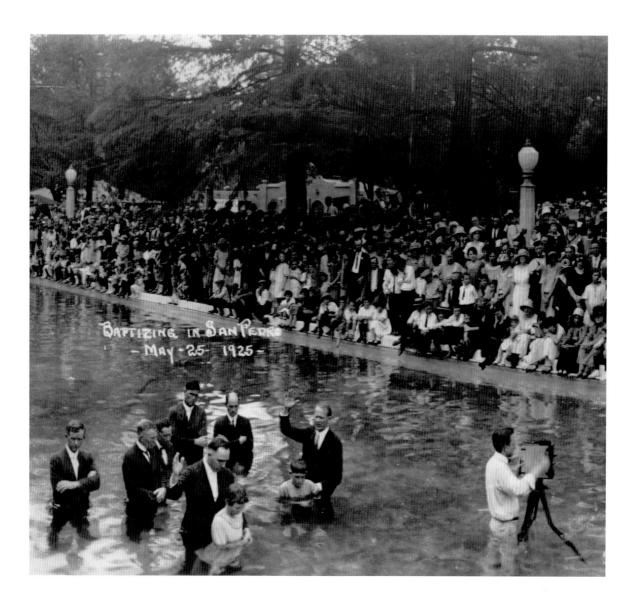

The text within the photograph reads:

BAPTIZING IN SAN PEDRO
— May ·25· 1925 —

Eugene Omar Goldbeck, Baptizing in San Pedro, May 25 (detail), 1925

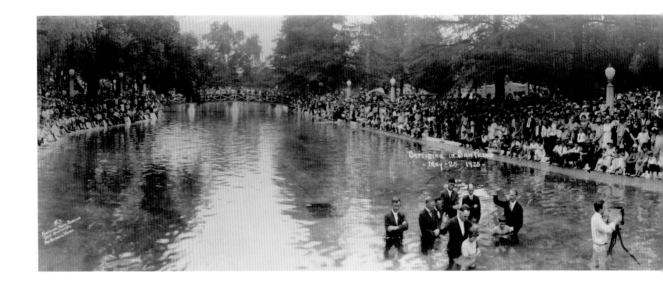

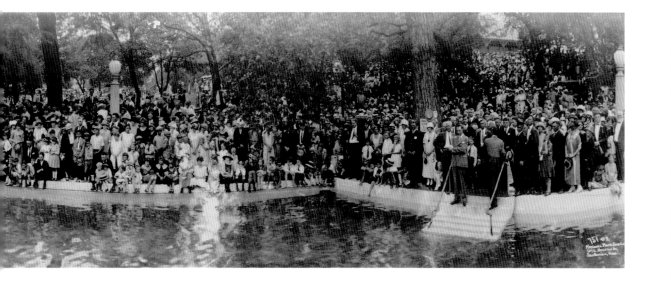

Eugene Omar Goldbeck, Baptizing in San Pedro, May 25, 1925

GIVING THINGS BACK

MARTIN WEINSTEIN, ALEC SOTH, AND DAVID E. LITTLE
IN CONVERSATION

AS: That's because of your passion for photography. Right now, you are working on a Eugene Smith exhibition, opening on March 8 [2013] at your gallery. Walking in this door right now, you immediately wanted to talk about W. Eugene Smith's work. We saw your *collector's* mindset. To me, what you're all about is the crazy collector obsession, even though you're a dealer. You've maintained it all this time. And I want to talk about the evolution from collector to dealer. Talk about that kind of raw instinctual passion for something. Where did that start? Was it photography, painting, baseball?

MW: You know people ask me, "Why is that a good image?" Many collectors and dealers want to follow my eye. I don't believe that you can articulate those things. I've always felt it was a gut thing. Why did I get interested in photography as a collector? You know it's just, the light bulb goes on. I like a whole range of photographs, from vintage black-and-white to large-scale color photography. But what really matters to me as a collector are the gut humanist images, and W. Eugene Smith made some of the best gut humanist images in the history of photography.

AS: But why now? What triggered your excitement about W. Eugene Smith?

MW: Over the years I've really liked his work. Ted liked his work. Ted accumulated it. I gave some. He bought some. But this was just a great photographer. Usually we do, at the gallery, one or two historically themed shows—solo exhibitions—a year. Last year it was Gordon Parks. And I'm looking around trying to figure out, what do we want to do for our next show? And about six months ago, I was in communication with Gene Smith's son; I've been buying pictures from him for fifteen years. The one image that he had that I've always wanted was *The Country Doctor*. The doctor is walking in a field with a satchel, and it was that photo essay on the country doctor in *Life* magazine that put Smith on the map, even more so than *The Walk to Paradise Garden*, which was in the "Family of Man" exhibition. I bought it from him, and I framed it up and had it hanging over my desk. And a few months later, I turned around and I said, "It's right there, why haven't we done this?

A show on W. Eugene Smith." A retrospective of his work was at the MIA in 1987, a traveling show. That monograph is still the best book on him. He hasn't been shown in the Midwest in a quarter of a century. He was also a master printer. Despite a million personal problems, getting wounded in World War II but also getting beat up, physically beat up, in Philadelphia and then in Japan.

AS: There's nothing trendy about Smith right now. But consistently, with your collecting and involvement in the art world, you've had to combine your populist, people-person style with the elitist world of an art dealer. The art world—the museum world, too, to an extent—it's an elite form. It's putting something up on a pedestal. And photography is a kind of lowly medium. It is a populist medium.

MW: There are all of these debates about whether photography is art, which have gone back to the medium's invention in the early to mid-nineteenth century. Since that time, there have been all of these amazing innovations in the field, more recently by digital images. I am not concerned with debates about photography as art. It is art. There is no doubt in my mind, and you can see that in my collection and my gallery exhibitions. Photography is photography. It is what it is and it should really matter. At some point it turned for me. It became a commitment to the medium.

AS: Was there a turning point in your collecting as well? Was there a certain picture that you remember buying?

MW: The picture that kind of sums it up, after all these years, is Todd Webb's *Avenue of the Americas, New York City*. I was in Stephen and Connie Wirtz's gallery in San Francisco and Stephen said, "Come on over here, Martin. I have something that I think you'd be interested in." It was the vintage print of Sixth Avenue, the Todd Webb picture. An eight-panel picture. It was lying on the floor in pieces and stacked. He said, "Is this something you'd be interested in?" I said, "Yes, I'll buy it." I didn't even ask how much it cost because I had seen the eight panels. I had walked on Sixth Avenue in Manhattan,

This conversation was conducted in the photography and new media department at the Minneapolis Institute of Arts on January 9, 2013.

DAVID E. LITTLE: Martin, can you describe the early days of photography at the MIA?

MARTIN WEINSTEIN: Sure. The first shows Ted [Hartwell, the MIA's founding curator of photography] mounted were in the hallways, not on the first floor, but in the basement. He developed a collection, really, on less than a shoestring, because photography was new to the MIA and was a fledgling field for collectors. He was very strategic about building a collection with few resources, collecting whole bodies of work: Walker Evans, one of the best-edited small collections of Evans, thirty or forty pictures plus the portfolio. Diane Arbus. He bought 125 Lewis Hines. He also started to collect some of the major figures of the day from the photo agency Magnum, such as Gilles Peress, Marc Riboud, and Werner Bischof. It was amazing getting those collections with virtually no budget at all.

DL: Yes, no doubt it was hard to raise funds given the state of photography. The photography market was being born, and photographers were just beginning to seriously edition their works. The value of photography was just beginning to be appreciated even though it was over a hundred years old. There were only a handful of galleries nationwide, such as New York's Light Gallery, founded in the early 1970s. The Association of International Photography Art Dealers (AIPAD) wasn't founded until 1979 and mounted its first annual art fair in 1980. Martin, this is why the passion and depth of your collection was remarkable. You were part of this first wave of collecting. What was it like with dealers in the 1970s and '80s?

MW: Well, photography dealers were like traveling salesmen. They would come to Minneapolis one after another with three or four black cases, unload their stuff. Ted would look at it, put some on reserve, and would buy when he could get the money. Ted put together a tremendous collection—one body of work after another. I don't know how he got it done. He loved collecting entire bodies of work, and Alec's Sleeping by the Mississippi was the last series he purchased before his death.

ALEC SOTH: I think it's good to talk about the collection; it is very important for the historical record. But this isn't the "MIA Collection by Ted Hartwell" show. Martin, you are being too modest about your contributions. This is the Weinstein collection show, and I think people are interested in your story and the evolution of a collector. Think about a person walking in. They want the human story.

DL: I agree, Martin. Tell us about your early collecting and how you got involved at the MIA.

MW: I was involved with the museum initially as a fan and a donor, giving prints to Richard J. Campbell and Dennis Jon in the Department of Prints and Drawings. I also brought my kids to the MIA all the time. The museum has been my family's home since I moved to Minnesota.

AS: But were you collecting at that point?

MW: I was. I had been collecting alone for a couple of years, and a dealer on the West Coast had said, "You must be friends with Ted Hartwell." I said, "No, who is he?" He said, "He's the curator of photography at the Institute. You two should get together. He's a great guy." I was collecting by myself; I was a loner. I got together with Ted, we hit it off, and we became inseparable. But I never wanted to sit on the board here. I never intended to get involved. It's not my thing. Meetings are not my thing, especially when I have to run them. When I eventually did join the board, sometime in the nineties [1992–1998], there was no doubt that I was this curiosity and that photography was not assimilated into this collection. Photography was not that highly regarded. Evan [Maurer, MIA director, 1988–2005] went about changing that and did a great job supporting photography. It was my goal on the board of trustees to get photography accepted as a full member of this institution. I think that may have been one of my best contributions. And, you know, it seems that I've spent thirty-five years trying to get photography accepted. Either what I did here or what I do at the gallery.

which is now Avenue of the Americas, many times. I remember those bars. And I remember all the shops. One, I think, is called Martin's restaurant. There was a store on the second level called Irving's something. It reminded me of a law partner named Irving, who always made me giggle. Irving's had some fancy pineapple drink for ten cents. In the far corner of the picture there was this fellow who clearly was holding a small bottle of liquor in a brown bag, and it reminded me of Louis Faurer's photograph *Eddie*, a picture that I love. But this was Todd Webb's version of it. He wasn't using a panorama camera. He made several different shots that he pieced together; he marked the pavement before shooting each section, so it all made sense visually. To me, that said it all. You can't get any better. I remember when a newspaper person interviewed me and specifically asked me about that image. I said, "You really know something? If you want to have an equivalent in paintings, I don't see the difference between that photograph and a Titian painting. (Although I said Titian painting, I'm not a big Titian fan. I like earlier work.) Well PS, the story was picked up nationally, and one day I get a letter from Todd Webb, who was then probably in his eighties, a lovely guy, living in Maine. He said, "A friend of mine sent me this newspaper article in which you'd compared my picture of New York, the eight-panel picture, to Titian." He said, "I've never received a compliment like that." We corresponded after that. This photograph has been up at the MIA for many years. It is well accepted as a crowd pleaser. I love standing back and watching visitors delight in the image. I feel so fortunate to have been able to share this with them.

AS: It's becoming clear that you are a populist and a formalist. When I think about things you love, August Sander, works that are populist and elegant, aesthetic—

DL: Yes, the balance of formalism and populism is one of the reasons why your gallery and its shows have succeeded in developing a new generation of collectors. You show important historical figures who create serious and well-constructed photographs of subjects that everyone can relate to. New collectors and visitors can understand

the talent of the artist, yet the pictures are approachable and not intimidating.

MW: I hope this book embodies that idea as well. To me, it's always about making a contribution. How can this [book] be a statement of something? Or mean something? How can it potentially inspire a young collector to contribute to his or her collection in the future?

AS: I still want to learn more about you as a collector, too. There is this drive to collect that, I think, is similar to the drive to make pictures. What's interesting to me about a collection is the drive; what causes a person to want this stuff? We do see the New York influence. We do see the populist aspect and the formalist aspect, but you're not a curator trying to fill every gap in a collection.

MW: Well, as I said earlier, I have gut feelings about photographs, which are informed, of course, by years of reading about the history of photography and looking at countless photographs. But often there is something in a picture that triggers an association. This happened with a picture that I saw in your Sleeping by the Mississippi series— the picture I saw that day I went into your studio on Franklin Avenue, which was about the size of this table at the time; it was an extremely small studio. The photograph was *Peter's Houseboat*. I looked at it and said, "Who washes a tie?" There was a pink tie on the clothesline. And I think that if you look at that picture you say to yourself, who is this guy?

AS: That is such an example of your taste, too. You're drawn to that picture, more so than other people who see it, in part because it's a very formal picture, and in part because it also evokes memories for you. And I love that about your collecting sensibility.

MW: I think that's what photography can bring. You're reliving all the moments of your life. And consciously making references to other photographs you have seen. You make a connection. It's so populist that almost anyone can make a connection. It may not be with this photograph or that photograph. People might have a rough time making connections with, say, abstract work that

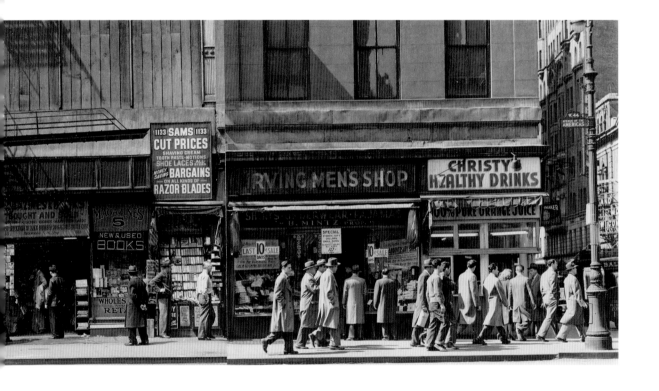

belongs in the art-speak world. But who could not make a connection with a picture like a Sander or an [Elliott] Erwitt?

AS: Well that's what I always say; it's the thing I love about photography, especially if you have a show and you can bring your kids or your grandma. But getting back to your drive to collect, I see a funny contradiction. You're a collector, which means you want to possess stuff. But you're famous for wanting to get rid of stuff—to give it away or sell it. You just flip it back into the world through the museum.

MW: Fleeting possession. I always say that really great stuff should be in the public domain. And my wife feels really strongly about it, too. You're just holding it for a while.

AS: When we arrived here today, the lobby was filled with about three hundred kids. Thinking about those kids or an older school group shuffling through your exhibition, is there anything you might want them to experience?

MW: It would be nice if the fidgeting is kept to a minimum. From my view, the responsibility for the meaningfulness of this show is in the hands of curator David Little. I've tried not to butt in. We've had discussions, but David has made the final selection from the works that I have given. Of the seventy images in the show and thirty or forty in the book, I would like to think that there will be certain images that people will look at and find some meaning in. For example, your picture of me in front of the house.

AS: Well, that's funny, because I was just going to talk about it.

MW: Let me just say, your picture of me in front of the house, if that doesn't give every single person who sees the show a good laugh . . . and if it *does* give everyone a good laugh, I don't need anything more than that.

AS: Let's say I had to give a tour to the school kids up in the gallery. I would walk up there, and I would say, "Look at this guy over here. He gave all these pictures to the museum. And here's a picture of a real pyramid, a very valuable picture that was given by this guy."

And then I would tell the story, which I think is funny, because Martin was in that zone, just like today with W. Eugene Smith. You get a great idea in your head and you want to share it with people. You were in that pyramid zone. You called me up: "Alec, there's the shadow of a pyramid on my garage! You have to come take a picture of it." OK. So I go to your house to photograph the garage.

MW: It's peeling. Although, for the record, after twenty-five years, we did repaint the garage.

AS: Yeah, it's peeling paint. But the thing that you saw, this phenomenon of the shadow on the house, which goes to your, not to be corny about it, but it goes to this formalism and this populist thing. This dumb garage, but this elegant shadow. It is a genuine—sort of—photographic moment. But for me, that's not 100 percent of what my interest is. My interest, in this case, is that you call me up to have me do this. So then I get a picture of you in front of it, and I love it, because it is so you.

DL: Martin, you didn't want to be in the picture at first, right?

MW: Yes, that's right, but Alec said to me, "No, no, no. You have to be in the picture." And so I ran upstairs and I put on a white shirt and black slacks, and I was still wearing slippers. I had an old straw panama hat and I had a cigar in my hand. It is a very funny picture. I think the picture is sold out.

AS: You look at the picture of the pyramid; this is this guy in south Minneapolis who walks to work, and he lives an average lifestyle, relatively speaking. And he assembled this collection, and he gave it back to the community. That's a great lesson for the kids—giving things back. ▲

TODD WEBB
120 NORTH ST.
BATH, MAINE 04530

DEAR MR. WEINSTEIN:

LAST APRIL I WAS AT ONE OF THOSE
AUTHORS BOOKSIGNING SHINDIGS IN PORT-
LAND AND A YOUNG MAN CAME UP WITH HIS
BOOK FOR ME TO SIGN AND AS HE WAS LEAV-
ING DROPPED A CLIPPING FROM THE MINNE-
APOLIS STAR TRIBUNE OF APRIL 11, 1992.
I WAS BUSY SO I FOLDED IT AND PUT IT
IN THE POCKET OF MY BLUE BLAZER I WEAR
FOR SPECIAL OCCASIONS.

YESTERDAY MY WIFE WAS GETTING MY
CLOTHES READY FOR ANOTHER SPECIAL OCC-
ASION AND SHE FOUND THE CLIPPING ABOUT
THE SHOW OF YOUR COLLECTION OF PHOTO-
GRAPHS. I WAS OVERWHELMED WITH THE
GOOD THINGS YOU HAD TO SAY ABOUT MY
AVENUE OF THE AMERICAS PANEL. I WAS
TOUCHED WITH THE THINGS YOU SAID ABOUT
NEW YORK. I DIDN'T DISCOVER IT UNTIL
I WAS FORTY YEARS OLD IN 1945 BUT IT
WAS LOVE AT FIRST SIGHT. WE WERE THERE
A WEEK AGO TO SEE A SHOW I WAS HAVING
AT THE HOUK FRIEDMAN GALLERY. THE CITY
IS STILL WONDERFUL BUT WHEN YOU ARE
IN YOUR LATE EIGHTIES IT TENDS TO SEEM
DIFFICULT.

I AM HAPPY THAT YOU WROTE SO NICELY
ABOUT THE SIXTH AVENUE PANEL IT IS ONE
OF MY FAVORITES TOO. HOPE YOU SAW MY
LAST BOOK, PHOTOGRAPHS AND MEMORIES. "LOOKING
UNIVERSITY OF NEW MEXICO PRESS DID IT. BACK"
I THINK IT IS WONDERFUL THAT YOU HAVE
GIVEN THE MUSEUM TWO HUNDRED PHOTOGRAPHS.
BEST WISHES.

SINCERELY,

Todd Webb

A.K.A TITIAN OR VAN GOGH

FROM THE HIP

ON SELECT PHOTOGRAPHS FROM
31 YEARS: GIFTS FROM MARTIN WEINSTEIN

MARTIN WEINSTEIN: From time to time I have acquired nineteenth-century images. Roger Fenton is one of the earliest war photographers; he took pictures of the Crimean War [1853–1856]. Although [Civil War photographers] Mathew Brady and Alexander Gardner are better known, Fenton was doing it a decade earlier; he was right there in the encampments with the soldiers and officers. In this picture, the commander is in the center; he is responsible for taking the troops into battle. But it is the strange figure off to the right, a soldier, which makes this picture for me. The soldier symbolizes death and the casualties of war, or he could be seen as an archangel protecting the troops. ▲

Roger Fenton, <u>Commander Ballan on the Staff of General Bosquet (Crimean War)</u>, 1855

DAVID E. LITTLE: This is a unique photograph of New York's World Trade Center. With Callahan, you don't get the monumentality of the building; it's a classic, minimalist Harry Callahan. But it's interesting: the Callahan photograph is about as far from [Bruce] Davidson's image [page 19] as you can get, and I like both. If you look closely, it is reminiscent of the lineal images he took of twigs and branches and also his ongoing series of Eleanor, his wife. You can almost see those same lines and structure. Some of those pictures had sexually suggestive allusions in the abstract forms of nature. This is great modernism here in terms of its refined structure. It certainly was produced in a very mature period for Callahan as a photographer. It also shows you, once again, Callahan's visual acuity; a lot of amateur photographers have done details of buildings, but few possess the graphic power and drama of this one. ▲

Harry Callahan, <u>New York</u>, 1974

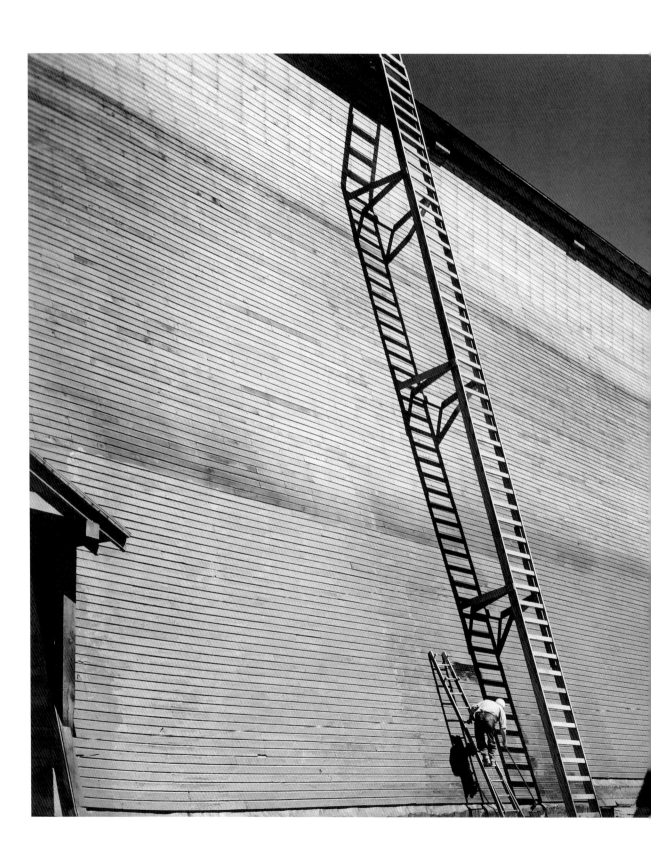

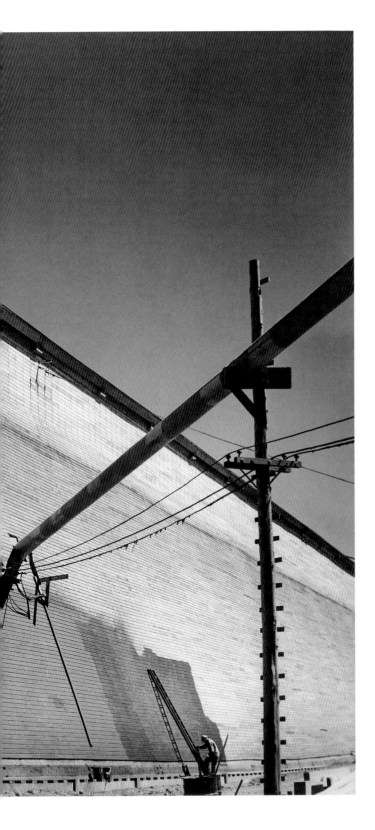

MW: As far as I can determine, this is one of the few projects Berenice Abbott did out west. The Red River Lumber Company was in California, but the company also existed in the Dakotas. I believe that the Red River company was owned by the James J. Hill family, and a group of the pictures probably made their way back. I purchased them from a lovely book dealer in Minnesota. I looked at them and I fell in love with them. I said, "I'll take the group." For me, it's a very dramatic picture, great composition, and it just has a great graphic presence. It is a large picture for her at the time: sixteen by twenty.

DL: Yes, the photograph's graphic presence and minimal composition are what make this picture for me. Abbott is best known for her photograph, *Nightview, New York* (1932), a stunning image of New York's skyscrapers at night, which is also in our collection and one of the docents' favorite photographs. That photograph is from a plane looking down on "the city," showing its bright lights and energy. It's one of those great New York images, like Woody Allen's scene in the movie, *Manhattan*, of fireworks exploding above Manhattan's skyline. Abbott took portraits of the greats—my favorite is her portrait of James Joyce—and everyday city scenes, such as stores and bakeries. Her pictures of those subjects are up close and intimate. But she tended to approach architecture from a distance, looking up or down with her camera to create dramatic angles and energizing compositions. She wants to communicate scale and grandeur and shows great reverence for human architectural achievements. ▲

Berenice Abbott, Shed Six, For Storage of Dry Lumber, Red River Lumber Company, California, 1943

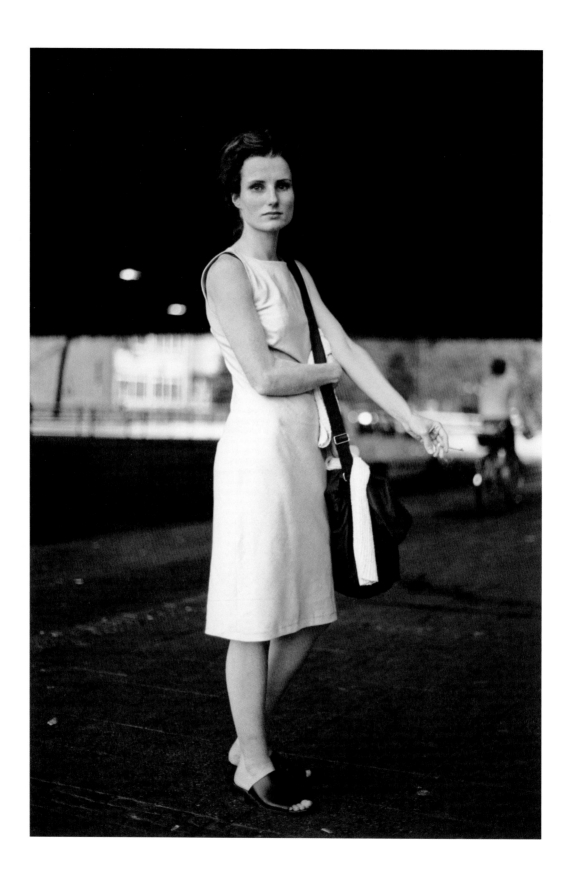

Zoltán Jókay, <u>Untitled</u>, 1998

MW: I saw this the first time the Weinstein Gallery was in Paris in 1999. A European dealer had this print. It's from about the same time that Rineke Dijkstra was doing her portrait work. I thought it was a great dead-on portrait. Is it one of the most important pictures of the collection? No. But it's a picture I've always loved. There's a great gallery story behind it, too. We had it shipped and unframed and, somehow, it disappeared. [My associate] Elizabeth Culbert and I went crazy trying to find the print. We looked over and over, for several years, and we could never find that picture. One day, I took another picture in to have something else put in the frame. The framer opened up the frame, and between that picture and the backing board was this picture that had disappeared for three years! Finally, it gets its due. ▲

MW: Ruzicka photographed the interior of the old Penn Station [1910], which looks very much like the existing Grand Central Station [1913]. He photographed it for more than twenty years from many different angles but always, of course, getting the great light. Although interiors can be very handsome in their own right, he really works with the crowd and the effect of the sunlight coming through the grand interior windows. I guess he wasn't called the Father of Light in Czechoslovakia for just any willy-nilly reason. He obviously had to capture that moment and went back many times. ▲

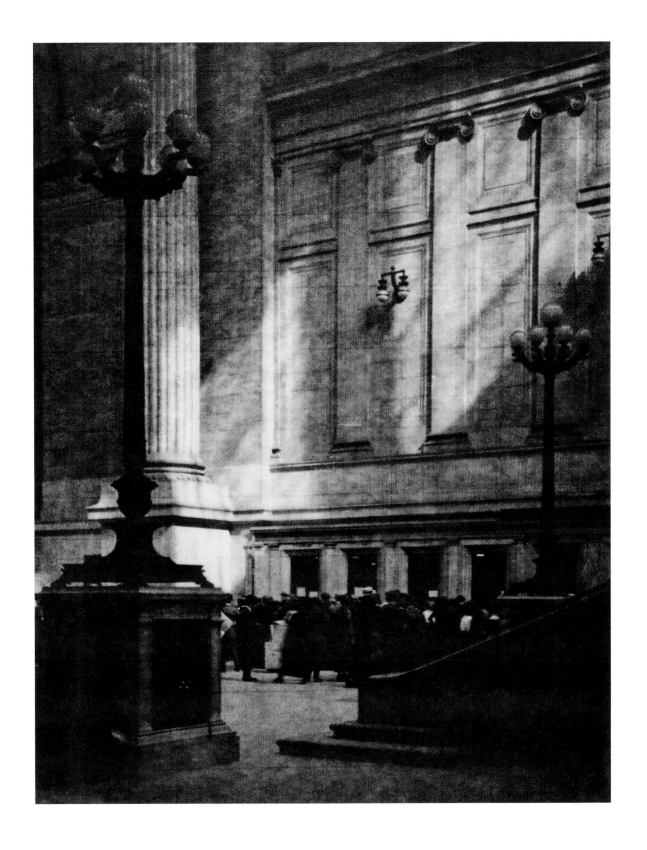

Drahomir Josef Ruzicka, Pennsylvania Station, New York City, n.d.

DL: Weston's *Nude* is more of a part nude—the ubiquitous breast in modernist photography, treated as if it were a still life. Female nudes have been an obsession of photographers ostensibly seeking out a perfect form and often using their wives, girlfriends, or potential lovers as subjects. Alfred Stieglitz and Georgia O'Keefe, Man Ray and Lee Miller, and the list goes on. This was not an exclusively male obsession. Ruth Bernhard made a career of photographing female nudes. In the spirit of Group f/64, Weston isolates the breast and photographs it at close range. He seems to seek out the stillness in forms, as he did in his famous *Pepper No. 30*. The result is an odd abstraction of reality. ▲

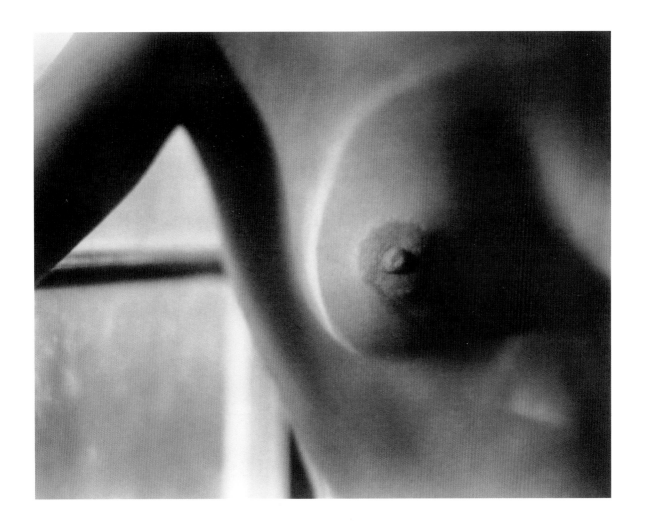

Edward Weston, Nude, 1922

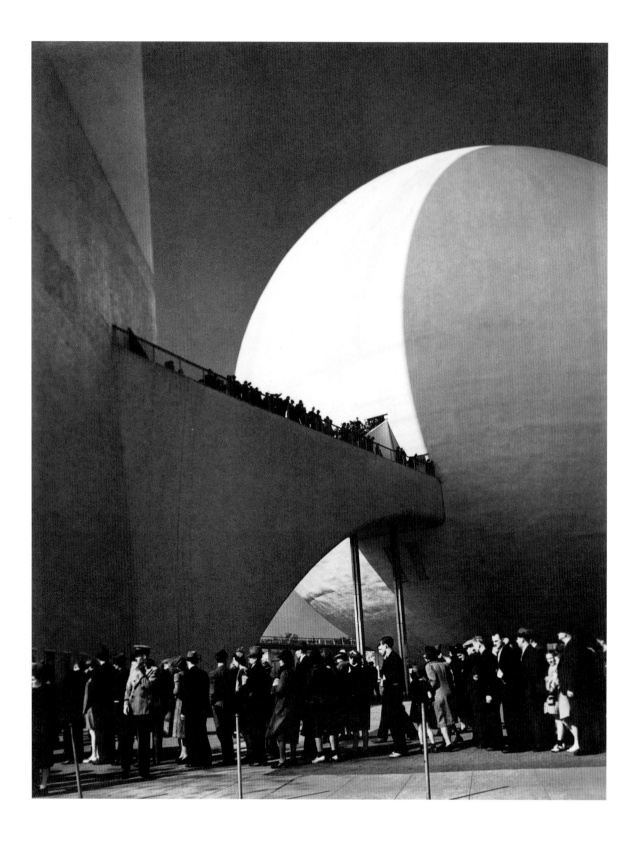

Drahomir Josef Ruzicka, Trilon and Perisphere, New York World's Fair, 1939

MW: Drahomir Josef Ruzicka was one of the leaders of the pictorialist movement in the United States, which spanned four decades from 1910 to the mid-century. The pictorialists were known for their soft-focus images and rejected the clarity and geometric compositions of modernists. As a group of amateur photographers, they sponsored exhibitions and competitions at small venues and museums across the U.S. and internationally. What is really amazing to see are the labels on the back of Ruzicka's pictures, which showed where they had been exhibited. This was before FedEx, and you just wonder how did this picture get to so many places in a relatively short period of time? Here's the Trilon at the 1939 New York World's Fair, and people were lined up to get inside. He was a pictorialist, as seen in the soft focus of this print; but this photograph is of a modern subject, the latest in architectural design. He shows he can do a modern picture of a modern subject. And the quality of the print is fabulous; pictorialists were known for their attention to craftsmanship—the artistry of creating an art object. His ability to make bromide prints, silver gelatin prints, was spectacular. ▲

MW: These images by Robert Adelman, Danny Lyon, and Burk Uzzle are essentially images of the workplace and represent American postwar productivity. What's interesting about the three images is that they show views of not only the white-collar worker but a kind of production line of information. I'm fonder of these images as a group than perhaps any singular one; they just work very well together. The Adelman image is so dead-on with the secretary sitting there, and you look through into the fancy glass office, and the three males are sitting around in their suits. It's so very fifties and sixties. It's so gender incorrect. In the Uzzle, you see what appear to be engineers working on design; it's almost like a production line, but instead of cars they're producing designs. These pictures are like the TV series "Mad Men."

DL: Yes, postwar productivity is on display here. It is about uniformity or conformity, which are attributes that, strangely, have a style. The photographs, for example, are similar and correspond visually, almost as a triptych, even though different photographers took them. Few styles are as recognized or codified or clichéd as those of the 1950s. These photographs are not meant to be documentary, in the sense of communicating an intended and overt message about business or the 1950s. But, from a historical distance, the message is clearly imprinted on the scenes. These are efficient people and spaces of a different era, with a strong whiff of masculinity. They have the smell of cologne, hair gel, and white shirts with extra starch.

MW: And the attitude.

DL: There's a mirror in the background [of the Uzzle photograph], so it reflects back, or it just goes on endlessly. This suggests the vastness and sameness of industrial production with the figures as cogs in the wheel. ▲

Robert Adelman, Untitled, c. 1960s

Danny Lyon, <u>Doyle-Dane-Bernbach, Inc.</u>, c. 1969

DL: Peter Beard's photographs typically represent his ties to fashion, travels in Africa, and New York social activity. This humorous and self-effacing diptych is a noteworthy exception. It is a sight gag that unfolds in a sequence from the artist standing on the left to the artist falling on the right. One can't help thinking that the photographs are infused with the spirit of Buster Keaton and Charlie Chaplin. The MIA's collection has many photographs of photographers, often playing the part of the brooding artist. Few have this informal slapstick humor. ▲

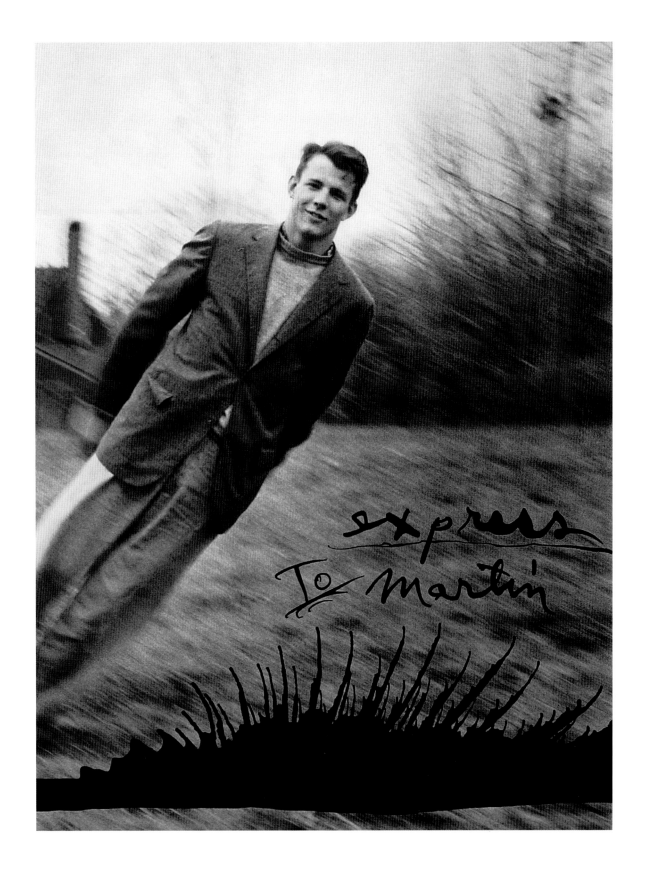

Peter Beard, Hallelujah the Hills, Vermont (detail), 1962

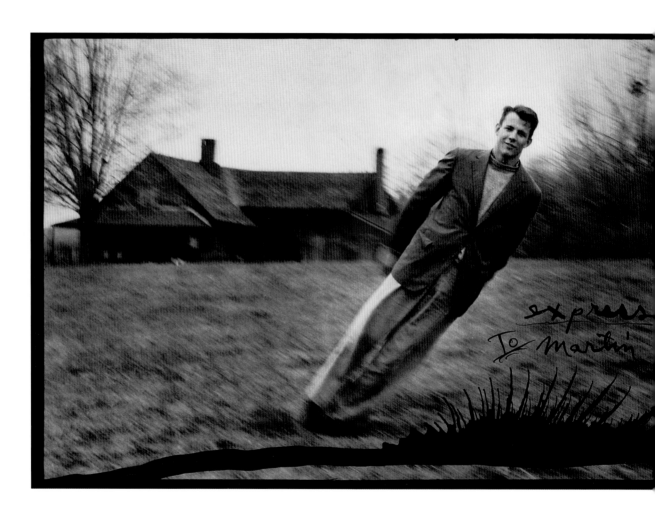

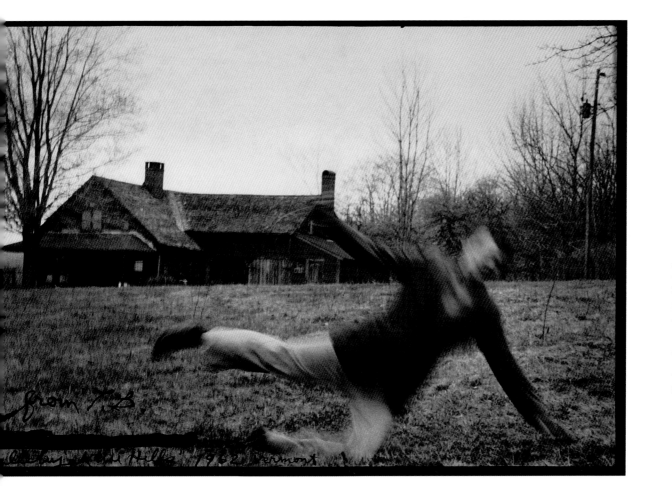

Peter Beard, Hallelujah the Hills, Vermont, 1962

MW: The jumping dog with the fellow you see from the knees down in his raincoat with his big shoes, in Paris. I think of the stupid pet tricks on the David Letterman show. But it's Elliott's humor. It personifies him. It's got a charm. It's wacky. It's different. It's just a great image. Sort of like Elliott's perspective on life. And it makes you warm and fuzzy and smile and be happy. What more should a photograph do?

DL: Humor is so hard to do in photography; it tends to be too obvious. But Elliott has good visual timing in his photographs, like a comedian telling a joke. Elliott's comic timing is better than any other photographer I can think of. It's not just a joke, but also has a much-broader philosophical point of view. ▲

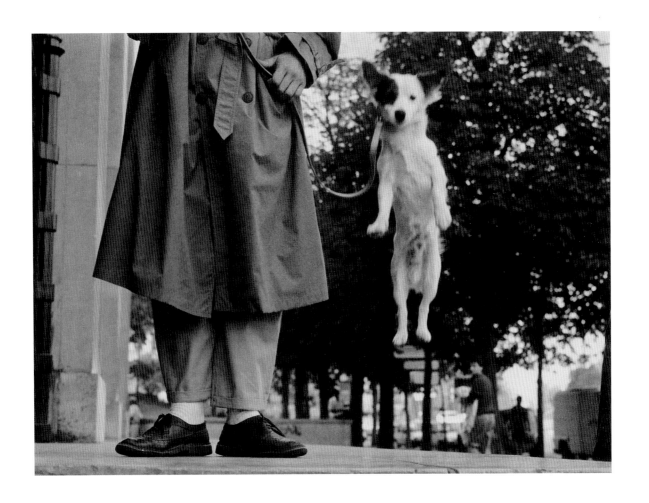

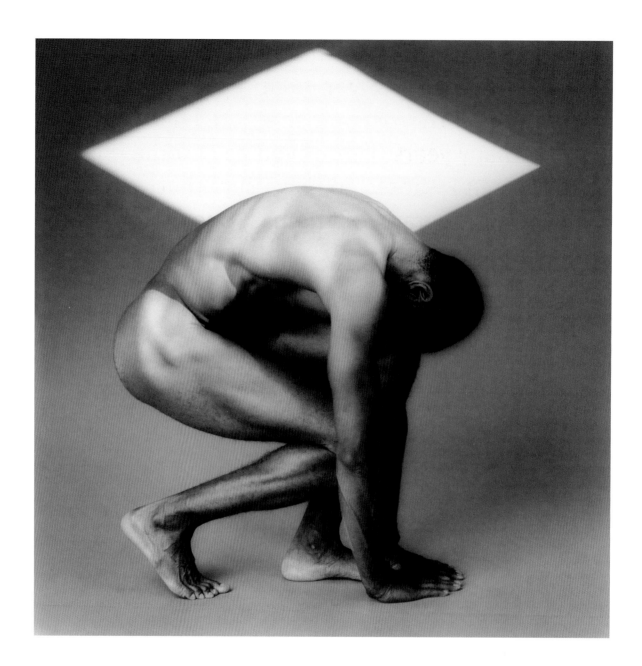

Robert Mapplethorpe, <u>Thomas</u>, 1987

MW: I was up last night and kept thinking how the MIA doesn't have a silver gelatin photograph by Robert Mapplethorpe, whose estate I have worked with for many years. I know you have some photogravures, but I wanted to make sure that you would have this photograph of Thomas, one of Robert's outstanding models.

DL: Thank you, Martin. This is a great addition to the exhibition and the collection. Mapplethorpe was at his best when he was photographing the nude. It's interesting to think of this work in comparison with his photograph of Arnold Schwarzenegger in "The Sports Show," where the young bodybuilder is in a raw studio, standing on wooden floorboards with a makeshift curtain to his right and white board as a background. That was no doubt a 1970s studio! And this is the 1980s, highly stylized with a geometric form in the background and a seamless floor that blends into the background. Thomas is rolled up, almost in a ball, so that his body just looks like a muscular form. There is very little revealed of his body as a sexual form. ▲

MW: I was preparing to do a show that had taken me about three years to put together. It was called "The Pyramids: 150 years of Photographic Fascination," and it began with early salt prints and included contemporary prints and digital images. The thesis being that the pyramids are perhaps the most photographed subjects of all time. In the 1850s, shortly after the beginning of photography, there were photographers in Egypt and the Middle East taking pictures with their giant cameras. They were called travel photographers, not because they traveled, but because they sold their photographs to travelers. All that came to an end with the advent of the Kodak Brownie camera [an inexpensive, easy-to-use box-shaped camera first introduced by Eastman Kodak in 1900]. Getting back to Alec's picture, I noticed that every afternoon when I returned home in the summer in July and June—because it stayed light quite late in the evening—there was a pyramidal shape of sunlight that occurred on the shingles of my garage. And, at that time, my gallery had pretty much just begun to do work with Alec. He was just starting out. I said to Alec, sort of casually one day when we were working on other things—we were including in the exhibition his image of a pyramid in Memphis— "You know, there is a great pyramid image that needs to be taken. It's this image that appears on the peeling paint of my garage." He said, "Yeah," and that was it. Frankly, I forgot about it after that. Several weeks later, [my wife] Lora and I went out shopping one Sunday for groceries. We came back and there's Alec and his camera all set up, blocking the driveway. I had told him what time the pyramid hit the garage. But, in any event, he's focusing and working on taking a picture and he says, "You should be in this picture." I said, "I'm not going to be in the picture." We had a five-minute battle over that, and I finally said OK. I ran upstairs, and I put on a white dress shirt and black pants. And you'll notice I'm wearing slippers; I never changed out of my slippers. And I popped on one of my straw hats. I happened to have a cigar in my hand. We spent a couple of hours making this photo. When I saw it, it really made me laugh.

We hung it in the show close to the window, facing the street. Well, a fellow called to say he was going to be reviewing the show for some paper and would stop by before we closed. We waited till five, five thirty, and he never showed up. And that was that. And then about two weeks later, someone sent us a copy of the article, in which he said he'd obviously not gotten into the gallery because it was closed, and he'd peered in through a window, and the thing that he could see most easily was the picture of me. So he wrote about the pyramid show and said his favorite image is of this old guy who looks like an American pharaoh. And my wife has called me the American Pharaoh for the last decade because of that. I have to admit, it's a funny picture and I really like it. Alec just calls it, *Martin Weinstein*. I think we should retitle it, *Martin Weinstein: American Pharaoh*. You can't beat that. ▲

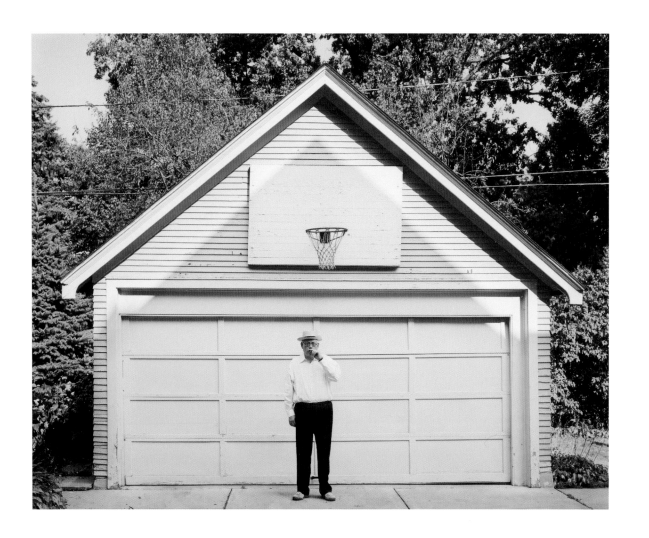

Alec Soth, <u>Martin Weinstein, Minneapolis, Minnesota,</u> 2003

EXHIBITION IMAGE LIST

31 YEARS: GIFTS FROM MARTIN WEINSTEIN

MINNEAPOLIS INSTITUTE OF ARTS

NOVEMBER 2, 2013–AUGUST 31, 2014

HARRISON PHOTOGRAPHY GALLERY

All objects are gifts of
Lora and Martin G. Weinstein.

All sizes are image size unless
otherwise indicated.

**Images set in bold are pictured
in this volume.**

Berenice Abbott
American, 1898–1991
Shed Six, For Storage of Dry Lumber, Red River
Lumber Company, California, 1943
Gelatin silver print
13¹⁵⁄₁₆ × 19¹¹⁄₁₆ inches
93.70.72
© Berenice Abbott/Commerce Graphics
Courtesy Howard Greenberg Gallery, New York

Ansel Adams
American, 1902–1984
Graduation Dress, Yosemite Valley, California,
1948
Gelatin silver print (printed 1974)
19½ × 15⁵⁄₁₆ inches
90.133.1
© 2013 The Ansel Adams Publishing Rights Trust

Robert Adelman
American, born 1930
Untitled, c. 1960s
Gelatin silver print
6 × 10⁹⁄₁₆ inches
91.123.30
© Bob Adelman

Thomas F. Arndt
American, born 1944
Pistol Range, Dachau, 1985
Gelatin silver print
12⅛ × 18¼ inches
91.122.49

Peter Beard
American, born 1938
Hallelujah the Hills, Vermont, 1962
Gelatin silver print (printed later)
6¼ × 18¾ inches (sheet)
2002.181.5
© Peter Beard
Courtesy of the Peter Beard Studio/
Licensing by Art + Commerce

Margaret Bourke-White
American, 1904–1971
Terminal Tower, Cleveland, 1928
Gelatin silver print
12⁹⁄₁₆ × 9¹¹⁄₁₆ inches
92.92.8
© Estate of Margaret Bourke-White/
Licensed by VAGA, New York, N.Y.

Horace Bristol
American, 1908–1997
Visitors at Yasukuni Shrine, Honoring War Dead,
c. 1945
Gelatin silver contact print
2³⁄₁₆ × 2³⁄₁₆ inches
2001.282.1

Harry Callahan
American, 1912–1999
***New York**, 1974*
Gelatin silver print
9⁵⁄₁₆ × 9¼ inches
84.125.2
© The Estate of Harry Callahan
Courtesy Pace/MacGill Gallery, New York

Cornell Capa
American, 1918–2008
Untitled, n.d.
Gelatin silver print
6⁵⁄₁₆ × 9½ inches
91.123.15

Bruce Davidson
American, born 1933
***East 100th Street**, c. 1966–1968*
Gelatin silver print
19¹⁵⁄₁₆ × 13³⁄₁₆ inches
89.125.9
© Bruce Davidson and Magnum Photos

Bruce Davidson
American, born 1933
Untitled [Man with umbrella, jumping], n.d.
Gelatin silver print
9 × 13³⁄₈ inches
93.70.57

Lynn Davis
American, born 1944
Moscow, Russia, 2003
Piezo print
10 × 10 inches
2005.145.11

(TWO PHOTOGRAPHS)
Robert Doisneau
French, 1912–1994
*Mariage Motillon-Bruneteau (Catholique et
Protestante), à Poneuf par St. Sauvant, Vienne*,
1958
Gelatin silver prints
15⁷⁄₁₆ × 11¹¹⁄₁₆ inches and 15³⁄₈ × 11¹¹⁄₁₆ inches
91.123.3 and 91.123.2

Elliott Erwitt
American (born France), 1928
***Paris**, 1989*
Gelatin silver print
20 × 24 inches
Recent gift
© Elliott Erwitt and Magnum Photos

Roger Fenton
British, 1819–1869
Commander Ballan on the Staff of General
***Bosquet (Crimean War)**, 1855*
Salt print (printed 1856)
7³⁄₈ × 5⁷⁄₈ inches
2008.85.3

Mario Giacomelli
Italian, 1925–2000
La Gente del Sud: Scanno, 1959
Gelatin silver print
11⁷⁄₈ × 15³⁄₄ inches
90.133.4

Frank W. Gohlke
American, born 1942
Grain Elevators and Lightning, Lamesa, Texas, 1975
Gelatin silver print (printed 1981)
14 × 14¹⁄₁₆ inches
84.125.12

Eugene Omar Goldbeck
American, 1892–1986
***Baptizing in San Pedro, May 25**, 1925*
Gelatin silver print
9¹⁄₈ × 48¹¹⁄₁₆ inches
89.125.2
© Goldbeck Co.

Hiroshi Hamaya
Japanese, 1915–1999
Untitled [Demonstrators and helmeted
authorities], c. 1962
Gelatin silver print
7³⁄₄ × 11¹¹⁄₁₆ inches
91.123.13

(THREE PHOTOGRAPHS)
Suzanne Hellmuth
American, born 1947
Jock Reynolds
American, born 1947
***Exchange**, 1982*
Gelatin silver prints
13¹³⁄₁₆ × 16½ inches (each)
82.133.1–3
© Suzanne Hellmuth and Jock Reynolds

Zoltán Jókay
German, born 1960
Untitled, 1998
Color coupler print
10¹⁄₁₆ × 6¾ inches
2002.181.7
© Zoltán Jókay

Stuart D. Klipper
American, born 1941
Lincoln Center (Portrait of a Man in the Subway), 1970
Gelatin silver print
4½ × 6 inches
89.125.3

Fred G. Korth
American (born Germany), 1902–1982
Galvanized Sheets, c. 1948
Gelatin silver print
13⅜ × 10½ inches
93.70.46

George Krause
American, born 1937
Girl and Vines, Spain, 1963
Gelatin silver print
3⁵⁄₁₆ × 4¹¹⁄₁₆ inches
92.92.15

Sergio Larrain
Chilean, 1931–2012
Couple Kissing, Chile, 1963
Gelatin silver print
12¹⁵⁄₁₆ × 9 inches
89.125.27

Helen Levitt
American, 1913–2009
New York, c. 1942
Gelatin silver print
10 × 6¹¹⁄₁₆ inches
84.125.3
© Estate of Helen Levitt

Jerome Liebling
American, 1924–2011
Dress, Paris, France, 1974
Gelatin silver print
12⅝ × 9³⁄₁₆ inches
86.110.5
© Jerome Liebling Photography

Jerome Liebling
American, 1924–2011
Paul Skjervold, DFL, 5th District Caucus, Minneapolis, 1962
Gelatin silver print
14¹⁵⁄₁₆ × 17⅞ inches
91.123.1

El Lissitzky (Lazar Markovich Lissitzky)
Russian, 1890–1941
Model for Meyerhold Theatre, 1929
Gelatin silver print
4³⁄₁₆ × 5⁹⁄₁₆ inches
93.70.47

Danny Lyon
American, born 1942
Doyle-Dane-Bernbach Inc., c. 1969
Gelatin silver print
6⁵⁄₁₆ × 9⅜ inches
89.125.29
© Danny Lyon and Magnum Photos

Robert Mapplethorpe
American, 1946–1989
Thomas, 1987
Gelatin silver print
19 × 19 inches
Recent gift
© Robert Mapplethorpe Foundation
Used by permission

Mary Ellen Mark
American, born 1940
Homeless Damm Family in Their Car, Los Angeles, California, 1987
Gelatin silver print (selenium toned)
15 × 14⅞ inches
2003.245.5
© Mary Ellen Mark

Mary Ellen Mark
American, born 1940
Tiny in her Halloween Costume, Seattle, Washington, 1983
Gelatin silver print (selenium toned)
22½ × 15³⁄₁₆ inches
2003.245.1

Jim Marshall
American, 1936–2010
Little Richard, San Francisco Civic Center, 1971
Gelatin silver print (printed 1998)
12⅛ × 8³⁄₁₆ inches
2002.181.8
© Jim Marshall Photography LLC

Roger Mayne
British, born 1929
At a Veterans' Cricket Match, Westminster School,
1961
Gelatin silver print
7⁵⁄₁₆ × 10½ inches
93.70.64

David McDermott
American, born 1952
Peter McGough
American, born 1958
(known as McDermott & McGough)
Behind the Seams (Cage), December, 1915, n.d.
Gum bichromate print
23 × 19 inches
2003.245.2

David McDermott
American, born 1952
Peter McGough
American, born 1958
(known as McDermott & McGough)
La Grande Odalisque: Anh Duong "1911," 2001
Palladium print
17 × 22 inches
2006.112.1

Gjon Mili
American (born Albania), 1903–1984
***Untitled*, c. 1950**
Gelatin silver print
9½ × 7 inches
89.125.30
Time & Life Pictures/Getty Images

Wayne Miller
American, 1918–2013
Untitled [Formerly titled *Lover's Embrace*],
c. 1946
Gelatin silver print
8³⁄₁₆ × 10 inches
89.125.19

Lisette Model
American (born Austria), 1901–1983
Sailor and Girl, c. 1940
Gelatin silver print
19 × 15½ inches
90.133.6

William Mortensen
American, 1897–1965
***Nicolo Paganini*, c. 1934**
Gelatin silver print and graphite
12¹¹⁄₁₆ × 10³⁄₁₆ inches
2007.138.3

Jean Mounicq
French, born 1931
*England, High Society, Bal dans
le Northamptonshire*, 1959
Gelatin silver print
7¹¹⁄₁₆ × 11½ inches
91.123.33

N.A.S.A.
U.S. Geological Survey, Segment 3, Sectors 9–10,
1966
Gelatin silver print mounted on paper
29¼ × 14½ inches (sheet)
94.101.14

N.A.S.A.
*U.S. Geological Survey, Segment 2, Sectors 7
and 8*, 1966
Gelatin silver prints, U.S. Geological Survey
grid paper, staples
30¾ × 14¾ inches (sheet)
2002.181.1

Homer Page
American, 1918–1986
Untitled, n.d.
Gelatin silver print
13¹⁄₁₆ × 8 inches
89.125.28

Robert Polidori
American (born Canada), born 1951
***Gas Station, Palm Springs*, 1997**
Fujicolor Crystal Archive print mounted
to Plexiglas
30¾ × 40 inches
2004.228.3
© Robert Polidori

Robert Polidori
American (born Canada), born 1951
Palm Court Inn, Highway 111, 1998
Chromogenic print
31⅛ × 40 inches
2004.228.4

Günter R. Reitz
German, active 1960s
Colleague in Izmir, Turkey, n.d.
Gelatin silver print
7⅛ × 7³⁄₁₆ inches
91.123.4

Hugh Rogers
American, active 1960s
Thanksgiving Day, Columbus Circle, New York City,
1958
Gelatin silver print
13⁷⁄₁₆ × 9¼ inches
91.123.36

Drahomir Josef Ruzicka
American (born Bohemia), 1870–1960
Ambition!, Chrysler Building, New York, c. 1930s
Gelatin silver print
13⁹⁄₁₆ × 9¹⁵⁄₁₆ inches
2008.103

Drahomir Josef Ruzicka
American (born Bohemia), 1870–1960
The Canyons of New York, n.d.
Gelatin silver print
13⅝ × 10¾ inches
92.92.2

Drahomir Josef Ruzicka
American (born Bohemia), 1870–1960
The National Bank of the City of New York, n.d.
Gelatin silver print
13⅝ × 10⅝ inches
92.92.3

Drahomir Josef Ruzicka
American (born Bohemia), 1870–1960
Pennsylvania Station, New York City, n.d.
Gelatin silver print
13⅜ × 10½ inches
93.70.52

Drahomir Josef Ruzicka
American (born Bohemia), 1870–1960
Trilon and Perisphere, New York World's Fair,
1939
Gelatin silver print
13⁹⁄₁₆ × 10⅝ inches
93.70.50

Drahomir Josef Ruzicka
American (born Bohemia), 1870–1960
Winter in Central Park, New York City, 1943
Gelatin silver print
13⅛ × 15¹⁵⁄₁₆ inches
90.133.12

August Sander
German, 1876–1964
Bricklayer, 1928
Gelatin silver print (printed by
Gunther Sander, 1983)
10³⁄₁₆ × 6⅝ inches
90.133.5
© 2013 Die Photographische Sammlung/
SK Stiftung Kultur—August Sander Archiv,
Cologne; ARS, New York

Arthur Siegel
American, 1913–1978
Right of Assembly, Detroit, 1939
Gelatin silver print (printed 1977)
16⁹⁄₁₆ × 13⁹⁄₁₆ inches
Given in honor of Carroll T. Hartwell
91.124.1
© Estate of Arthur Siegel

Raghubir Singh
Indian, 1942–1999
A Village Well in Dusty Winds, Jodhpur District,
India, c. 1980
Dye transfer print
12⁷⁄₁₆ × 18¹⁵⁄₁₆ inches
84.125.1
Photograph © Succession Raghubir Singh

Aaron Siskind
American, 1903–1991
Rome 73, 1963
Gelatin silver print
18¾ × 14¹⁵⁄₁₆ inches
90.133.2
Courtesy the Aaron Siskind Foundation

W. Eugene Smith
American, 1918–1978
Death of a Salesman, c. 1949
Gelatin silver print
10⁷⁄₁₆ × 13⁷⁄₁₆ inches
94.101.11

Cornel Somogyi
American (born Hungary), 1909–2001
Street, Budapest, c. 1930
Gelatin silver print
2⅜ × 1¹¹⁄₁₆ inches
90.133.8

Alec Soth
American, born 1969
Falls #26, 2005
Chromogenic print
40 × 50 inches
Recent gift
© Alec Soth

Alec Soth
American, born 1969
Martin Weinstein, Minneapolis, Minnesota,
2003
Archival pigment print
32 × 40 inches
Recent gift
© Alec Soth

Doug Starn
American, born 1961
Mike Starn
American, born 1961
Blot Out the Sun No. 4, 1999–2000
Lysonic ink jet print on Thai mulberry and tissue
papers, wax and encaustic and wood frame
21 × 22⅝ inches (including mount)
2002.181.2

Louis Stettner
American, born 1922
Promenade, 1954
Gelatin silver print (printed 1987)
7¹¹⁄₁₆ × 11⅝ inches
89.125.14

Burk Uzzle
American, born 1938
Auto Boom in Detroit, **c. 1960s**
Gelatin silver print
6⅝ × 9⁹⁄₁₆ inches
91.123.31
© Burk Uzzle

Roman Vishniac
American (born Russia), 1897–1990
*In Happier Times, in ORT-OSE Summer Camp,
Vilna*, 1934
Gelatin silver print
5¾ × 4¼ inches
91.124.6

Todd Webb
American, 1905–2000
Avenue of the Americas, New York City, 1948
Gelatin silver prints
10⅝ × 83⅝ inches
Given in memory of Joseph A. Weinstein
84.125.4
© Todd Webb
**Courtesy of Evans Gallery and Estate of Todd
and Lucille Webb, Portland, Maine USA**

Weegee (Arthur H. Fellig)
American (born Austria-Hungary), 1899–1968
Louis Armstrong, **c. 1950**
Gelatin silver print
9¹⁄₁₆ × 7⁹⁄₁₆ inches
89.125.4
ICP/Getty Images

Edward Weston
American, 1886–1958
Nude, **1922**
**Platinum print (printed under
supervision of Cole Weston)**
7¼ × 9⁵⁄₁₆ inches
89.125.6
Collection Center for Creative Photography
© 1981 Arizona Board of Regents

Garry Winogrand
American, 1928–1984
Jackie Robinson at Home in Connecticut, **1961**
Gelatin silver print
18⁷⁄₁₆ × 12⁵⁄₁₆ inches
86.110.3
© The Estate of Garry Winogrand
Courtesy Fraenkel Gallery, San Francisco

COLOPHON

This book was published in conjunction with the exhibition "31 Years: Gifts from Martin Weinstein," held at the Minneapolis Institute of Arts, November 2, 2013, through August 31, 2014.

Generous Support was provided by Maslon Edelman Borman & Brand, LLP.

Editor: Laura Silver
Designer: Matthew Rezac
Catalogue photography: Amanda Hankerson
Digital image production: Joshua Lynn
Publishing and production management:
Jim Bindas, Books and Projects LLC,
Minnetonka, Minnesota

© 2013 Minneapolis Institute of Arts
2400 Third Avenue South
Minneapolis, Minnesota 55404
www.artsmia.org

Printed in Singapore by Tien Wah Press

Library of Congress Control Number:
2013940393
ISBN: 978-0-98937-180-3

MINNEAPOLIS
MIA
INSTITUTE
OF ARTS